Bubbe, the Wind, and Me

by Norma Slavit

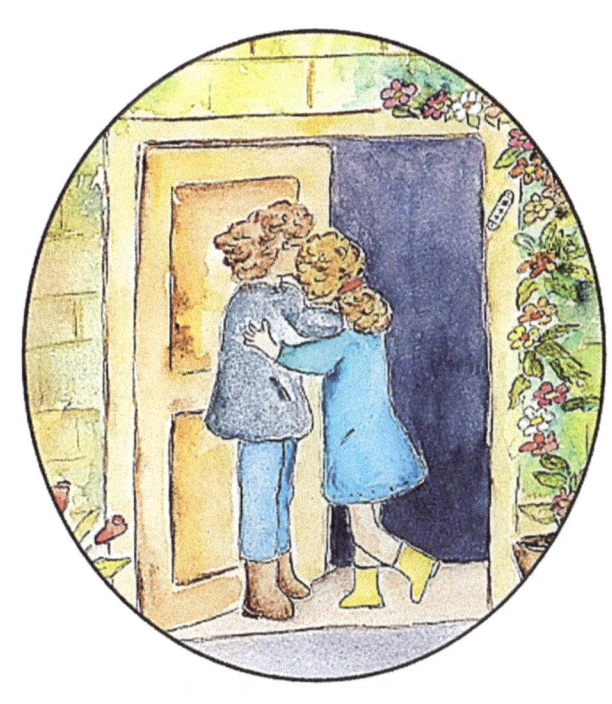

Illustrated by Elvira Rascov

Bubbe, the Wind, and Me

Copyright © 2021 by Norma Slavit
All rights reserved

ISBN: 978-0-578-97655-6

Published by Norma Slavit, San Jose, California 95129.

Printed in the United States of America.

All text in this book is copyrighted © 2021 by Norma Slavit.

PUBLISHER'S NOTE: All rights reserved. No part of this book may be reproduced in any form without permission in writing from the publisher.

In the event Norma Slavit is not available, her son, Joel Slavit of San Carlos, California 94070, will act in her behalf for any business pertaining to this book.

Illustrator: Elvira Rascov, San Jose, California 95118.
Although all art was purchased by the author, Norma Slavit, Elvira Rascov, was given the rights to the illustrations. No art from this book may be reproduced without permission in writing from the illustrator, along with credit given to the author and this book.

Luanna K. Leisure, San Jose, California. Little White Feather Graphic Artist and Independent Publisher.

Photos on page 30 and 44 taken by Luanna K. Leisure, Photography.

To order additional books go to: **http://www.LuLu.com, Amazon.com or Barnes&Noble.com**

Email: nslavit@hotmail.com

Book Dedication

I dedicate this book to my beloved mother, Rose Kaufmann. She was Joel and Lisa's loving and devoted grandmother. Always putting her family first, she inspired me by showing loving kindness to a myriad of people whose lives she touched.

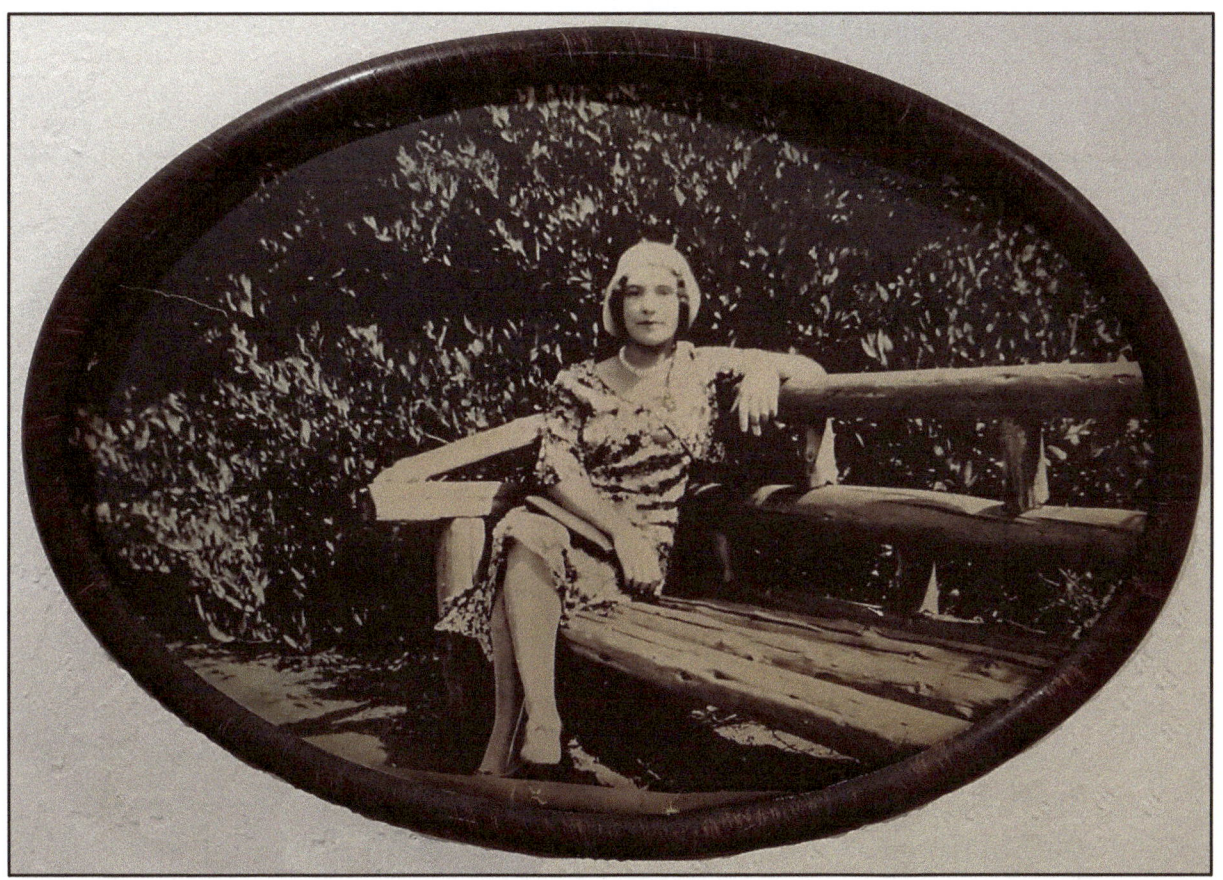

Beloved Mother, Rose Kaufmann
1909 – 1998
Picture taken in San Francisco's Golden Gate Park c. 1930

To the memory of my father, Max Kaufmann, who was always there for me.

To the blessed memory of my beloved husband, Herb.

And, also dedicated to my three wonderful grandchildren: Ilana, Rachel and Joshua and to their parents Joel and Betsy Slavit, and Lisa and Steve Barkin.

Special Acknowledgements

A special note of thanks to Rabbi Dana Magat for writing the foreword to this book.

To the friendship, over many decades, of women whom I admire: Ann Gershanov, Jackie Naftaly, Leah Bernstein and Amalia Arndt. As well as my dear cousin, Lucy Reisch, Irma Shapiro, Aunt Maxine Cohen and Kay Barkin.

Since this book is about grandmothers, I am reminded of a friend I have known since third grade. At the time of this printing, Bernice Trullinger, had 18 grandchildren, 20 great grandchildren and three more on the way.

This book was inspired by my first grandchild, Ilana, who was a toddler when this book was first written. The text is woven around events based on our walks together which often became magical encounters.

To my dear fiancée, Paul Staschower, for his love, emotional support and commitment.

A special thank you to Luanna Leisure who has guided me throughout the publishing process.

Foreword From Rabbi Dana Magat

This sweet and magical story brings to light the precious nature of the grandparent/grandchild relationship, focusing on what is most important — sharing our time and our love with our "Bubbe." The flow of time and the deepening of the relationship is what makes this story hit close to home.

I think on some level anyone can relate to this book, but it is extra special for a grandchild and grandparent. For those of us who are blessed with grandchildren, we understand how dear and precious our grandchildren truly are in our lives. For as we follow the wind, we recognize that we are part of a family chain from one generation to the next. And in the end, our grandchildren's hearts are our homes.

Rabbi Dana L. Magat
Temple Emanu-El
1010 University Ave
San Jose, CA 95126
(408) 292-0939
www.templesanjose.org
2021

A Note From the Author

This book was inspired by treasure walks I took with my first grandchild, Ilana. Allowing our imaginations to roam freely, we turned simple walks into enchanting encounters.

I wrote this book when Ilana was a toddler, put it aside, then revised and crafted a new ending recently during days of the 2020-2021 world pandemic.

The story highlights a special relationship between a grandchild and her grandparent. I feel now, as I felt then, the best gift a grandparent can give a grandchild is to show love and spend quality time together— everlasting gifts to treasure.

About the "Free Verse" you are about to read

Free verse can be defined as poetry "free from limitations." Rather than consistent patterns of punctuation and rhythm, it is an artistic expression of the author's use of sound and imagery.

Special Words and Jewish Traditions Found in This Book

BUBBE

The word Bubbe (buh-bee) can be spelled and pronounced a few different ways. Throughout this book, sometimes the word "Bubbe" and grandmother appear in the same sentence. Regardless how the reader sees the word spelled or hears it pronounced, Bubbe is a word many Jewish children endearingly call their grandmother.

SHABBOS

In Judaism, this is another word for the Sabbath, the seventh day in the week. The Sabbath begins approximately at sun-down Friday night, and continues to its culmination Saturday evening at sun-down. It is a tradition, in many Jewish homes, to light candles and say special prayers and blessings. In our story, grandmother has her own special Sabbath traditions—taking a mystical walk with her granddaughter is one of them.

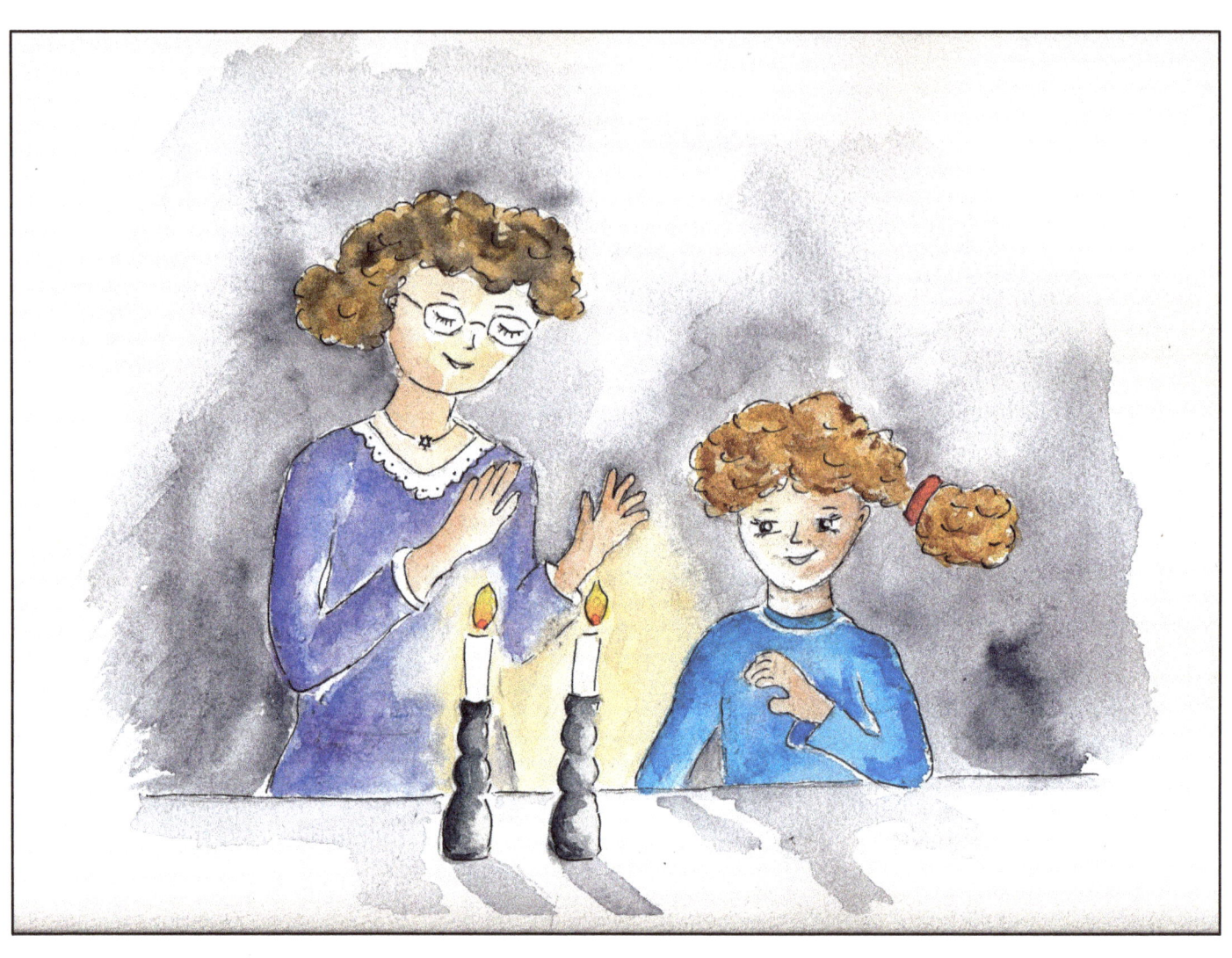

TRADITION -- TRADITION

In many Jewish homes it is a tradition to say a special blessing over the Sabbath candles on Friday evening.

Take a walk with your Bubbe
That's her Shabbos rule
 Spend 30 minutes or 60
 Grandma's time for just you.

A time to be silent
A time to talk
 Any time's the right time
 To go for a walk.

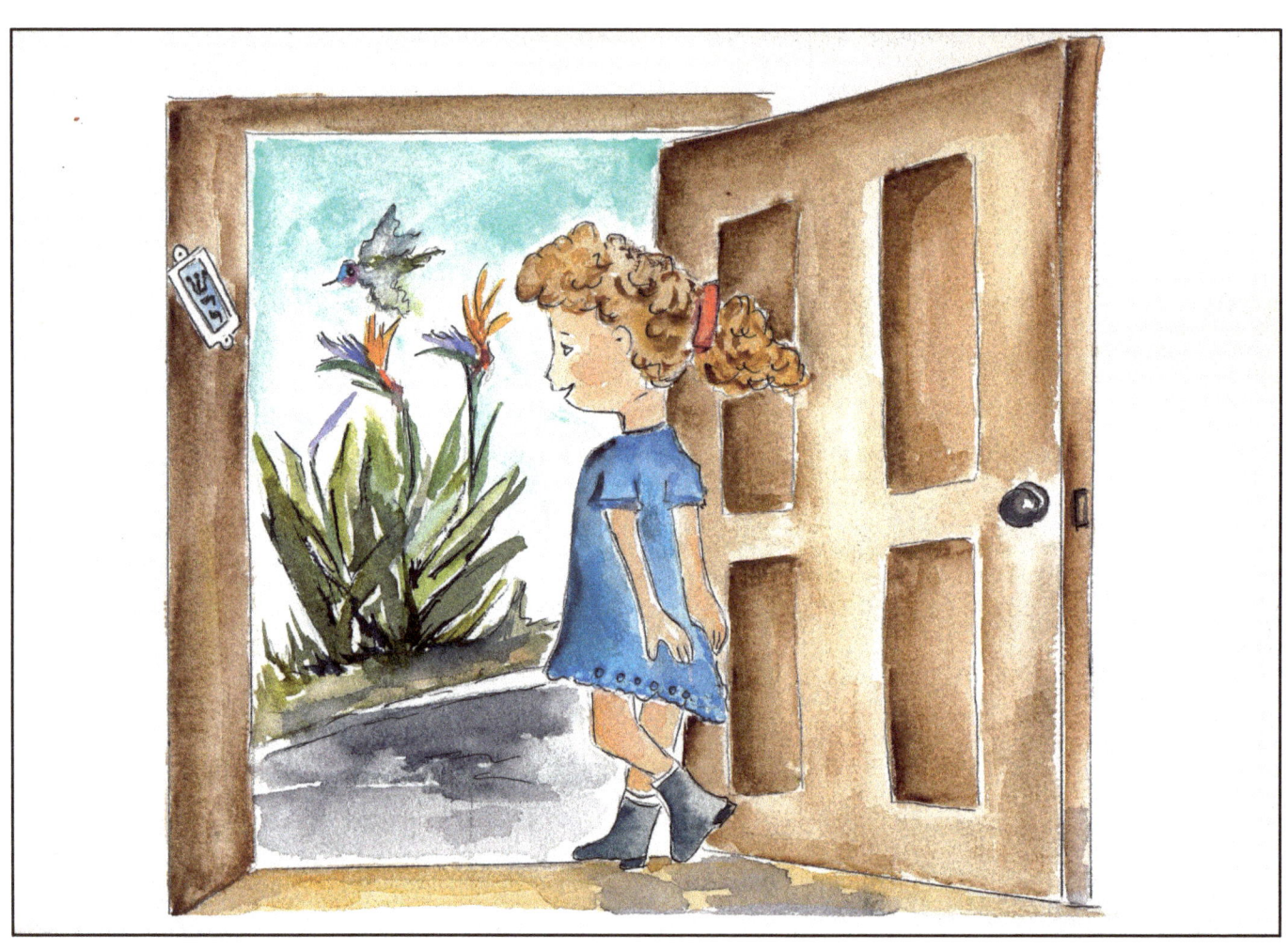

So many treasures

Outside your front door

Take time to gaze

Collect and explore.

Treasures are found

In most any space

In the city or country

Is a pretty good place.

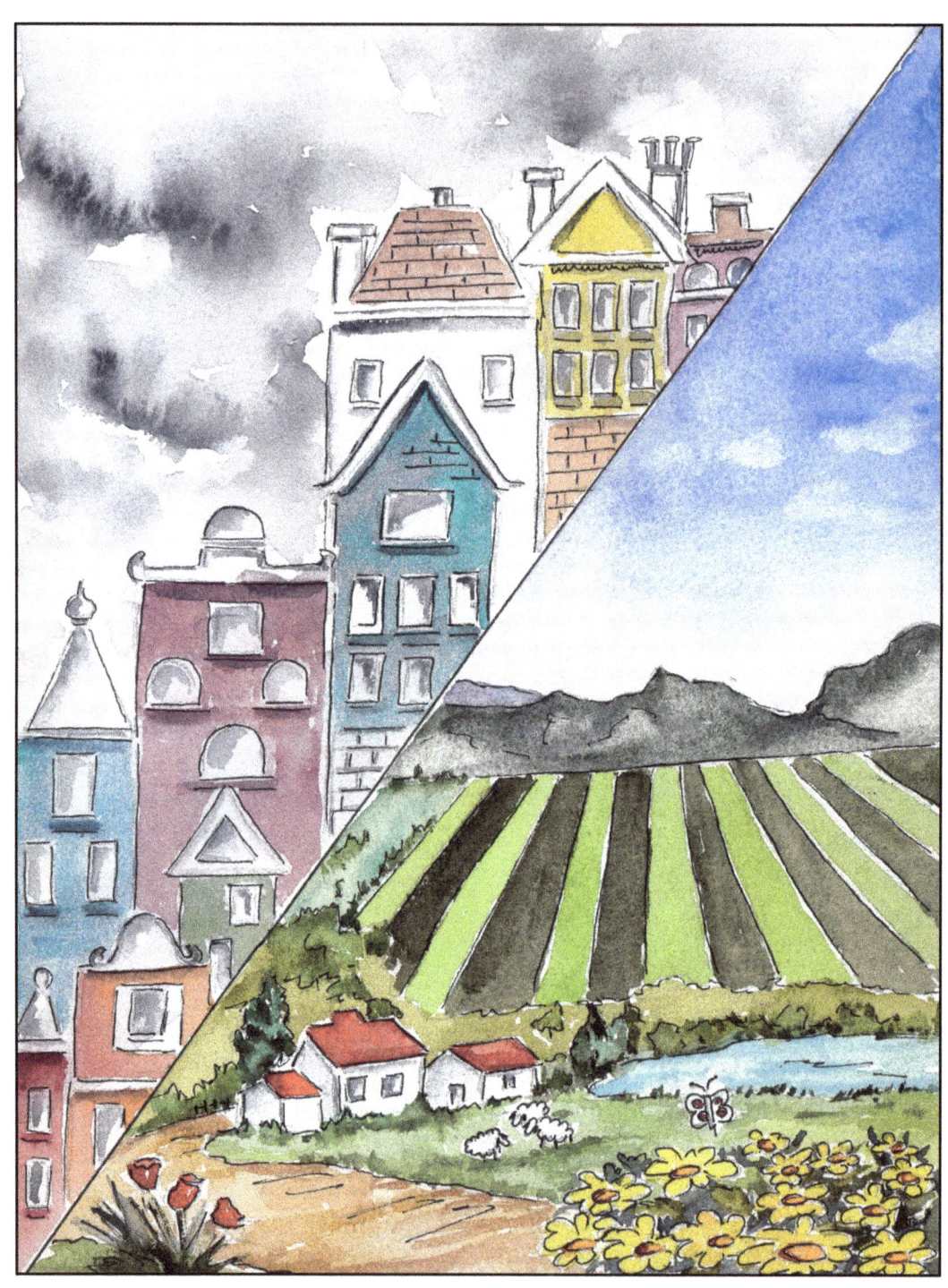

Just Bubbe and me

Come rain or come shine

 Any time with Grandma

 Is a very good time.

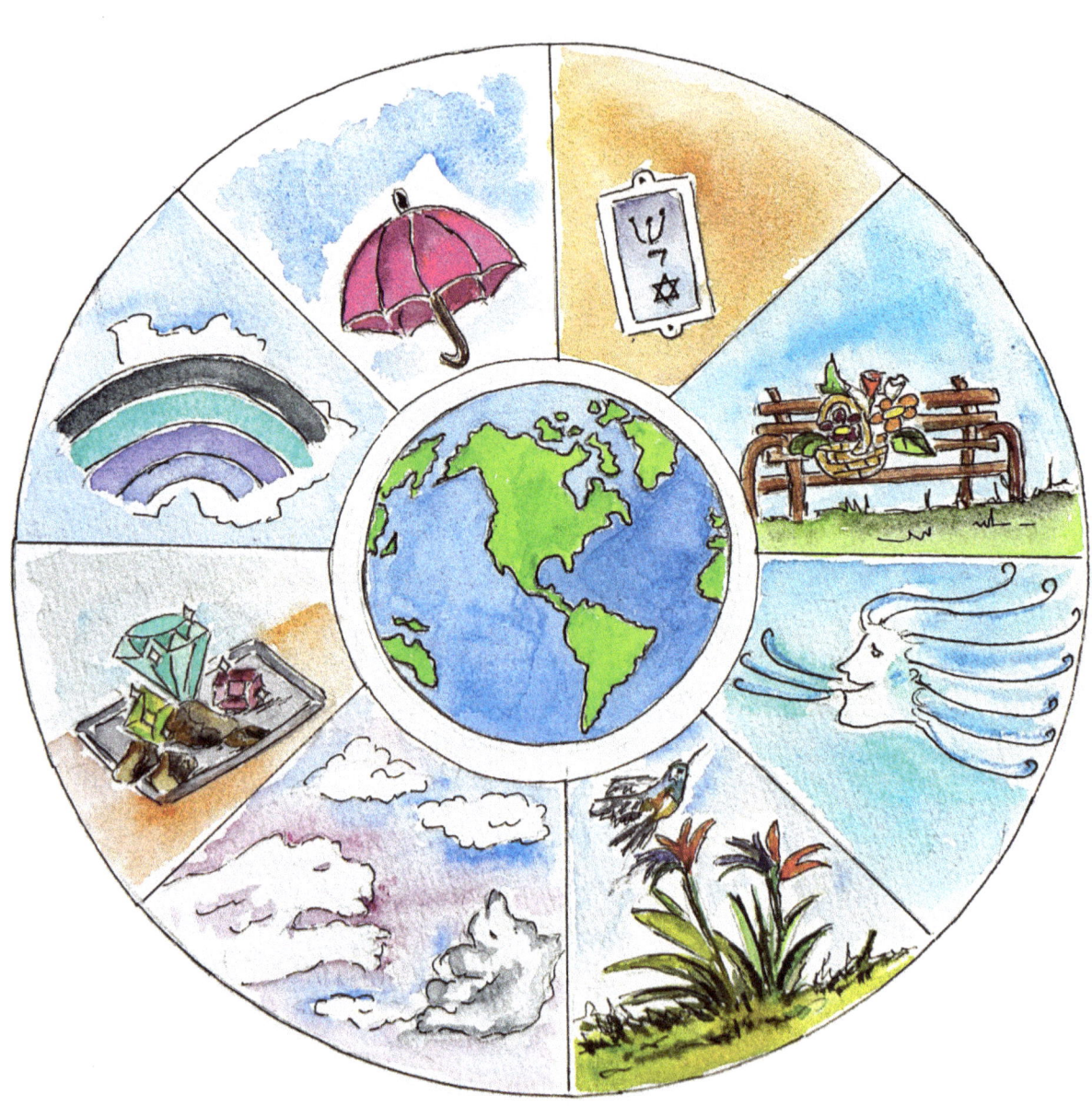

Walk with your Bubbe

That's her Shabbos rule

 When I walk with my Grandma

 The world is our school.

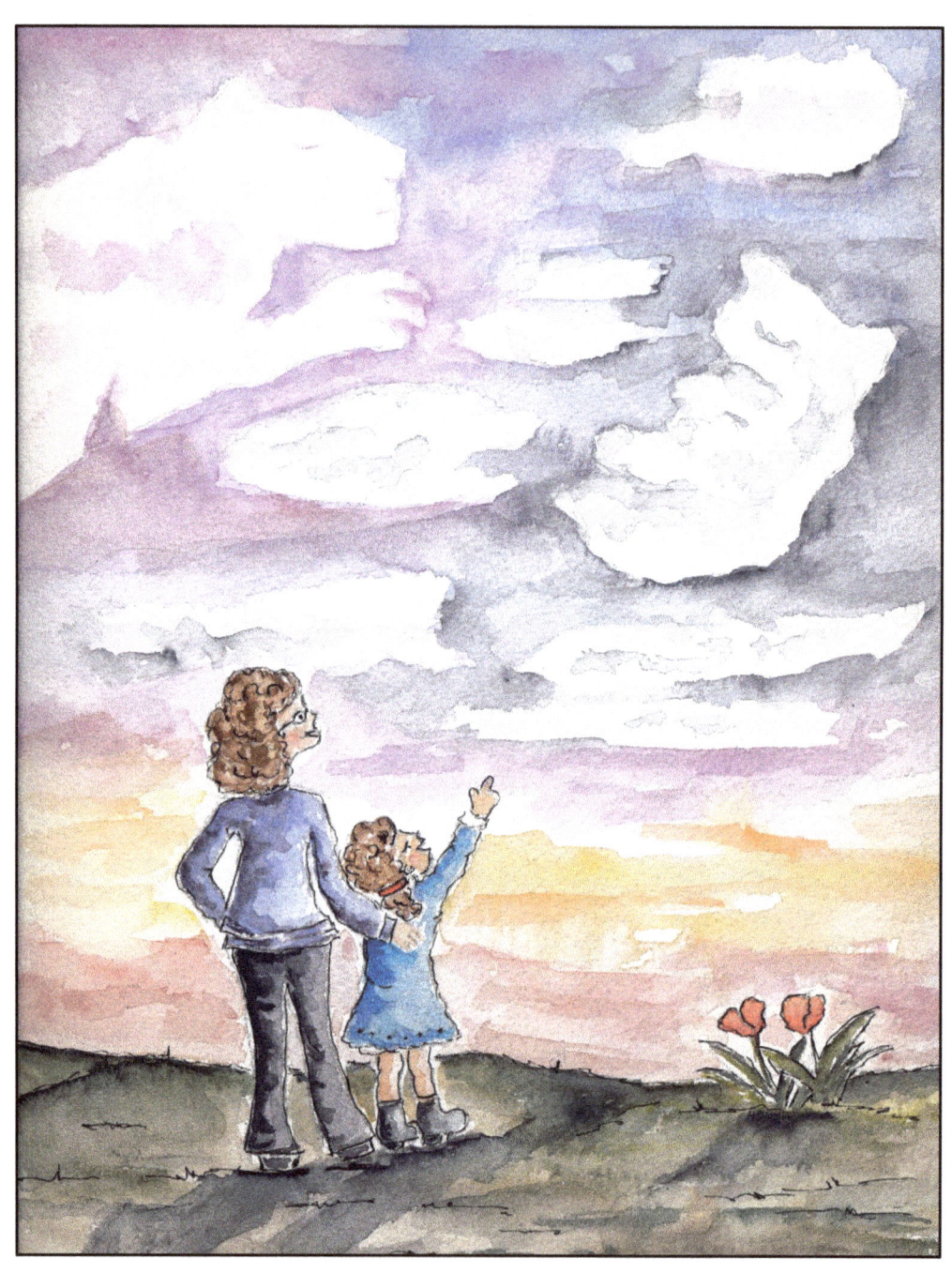

"Look up," says Bubbe,

"See clouds floating by

 Grey bears and red tigers

 To the curious eye."

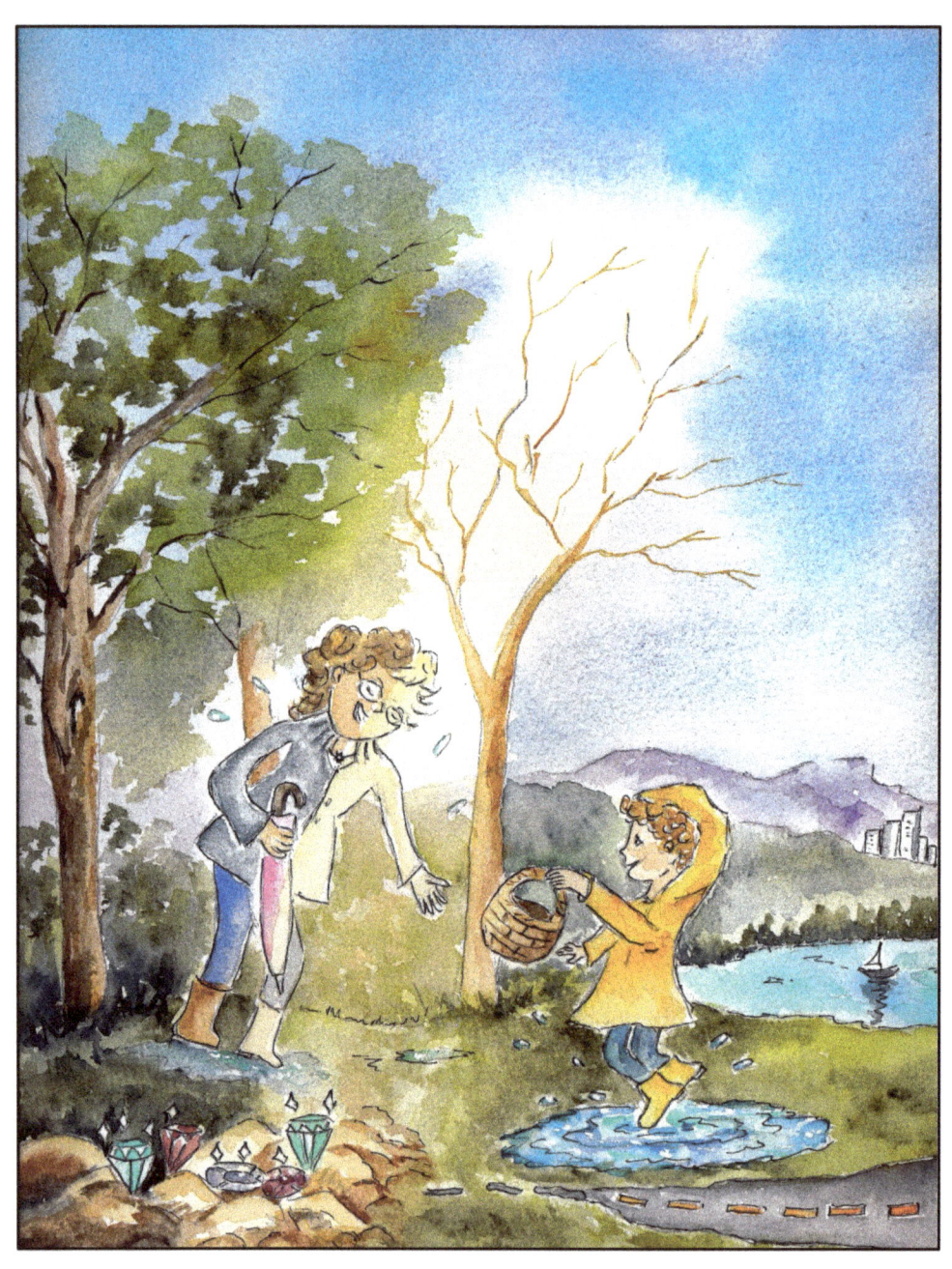

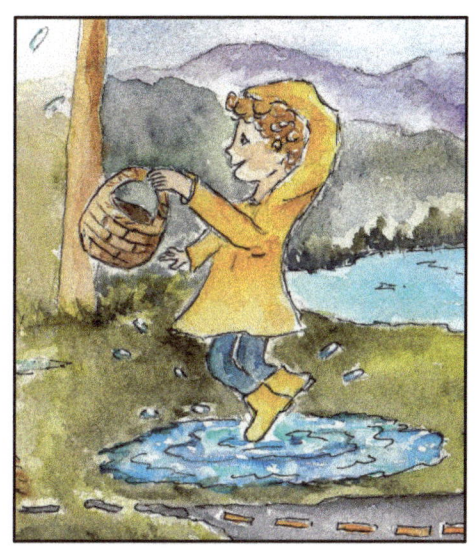

Bubbe turns cracks into roads

Puddles become pools

 When I blink my eyes

 She turns rocks into jewels.

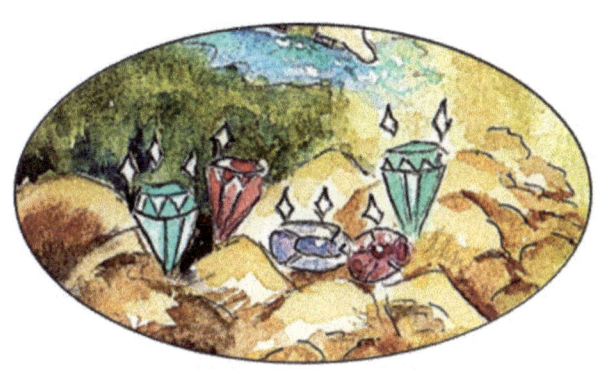

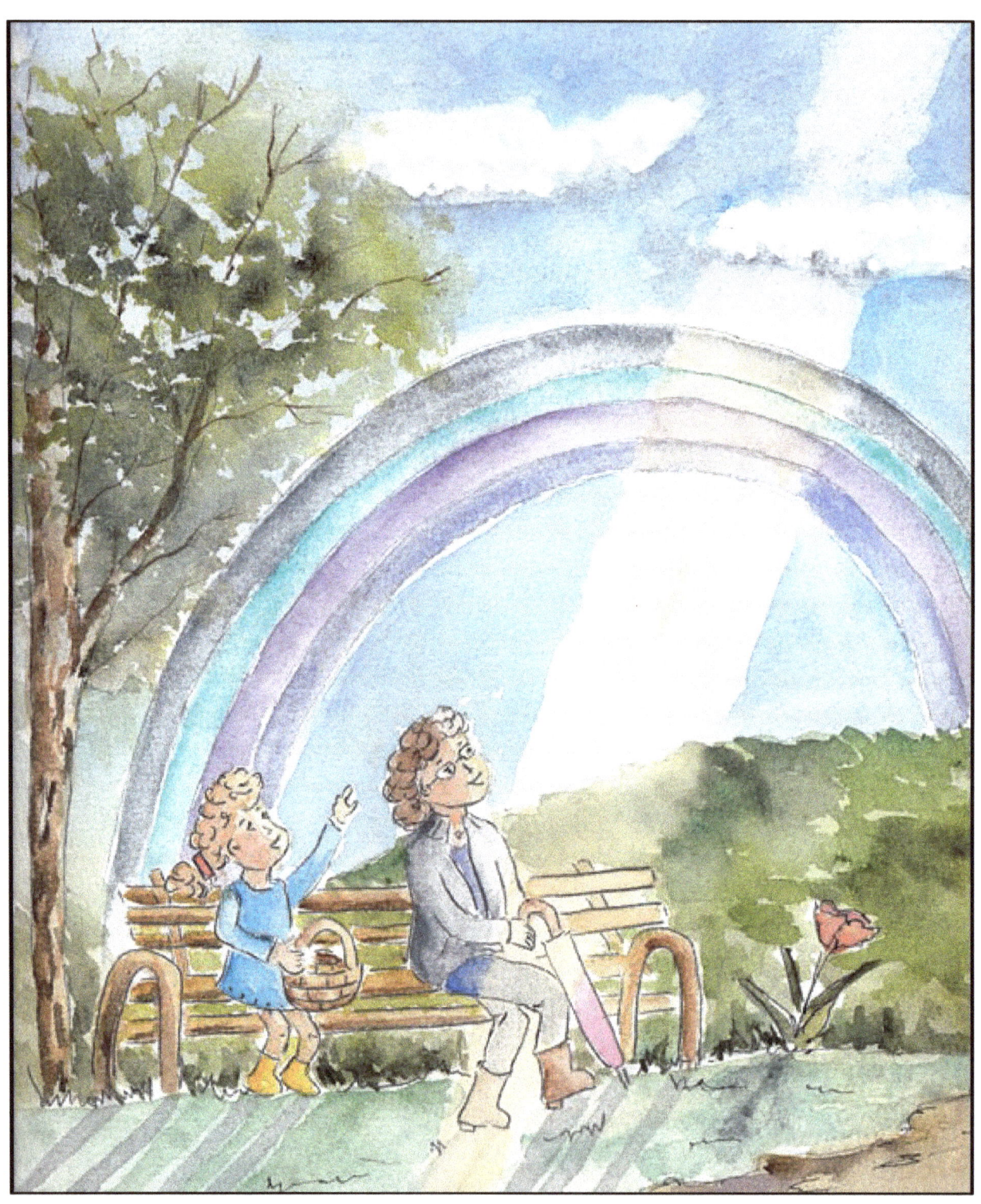

Lavender grey

Ebony green

 Contractions of colors

 Only Bubbe has seen.

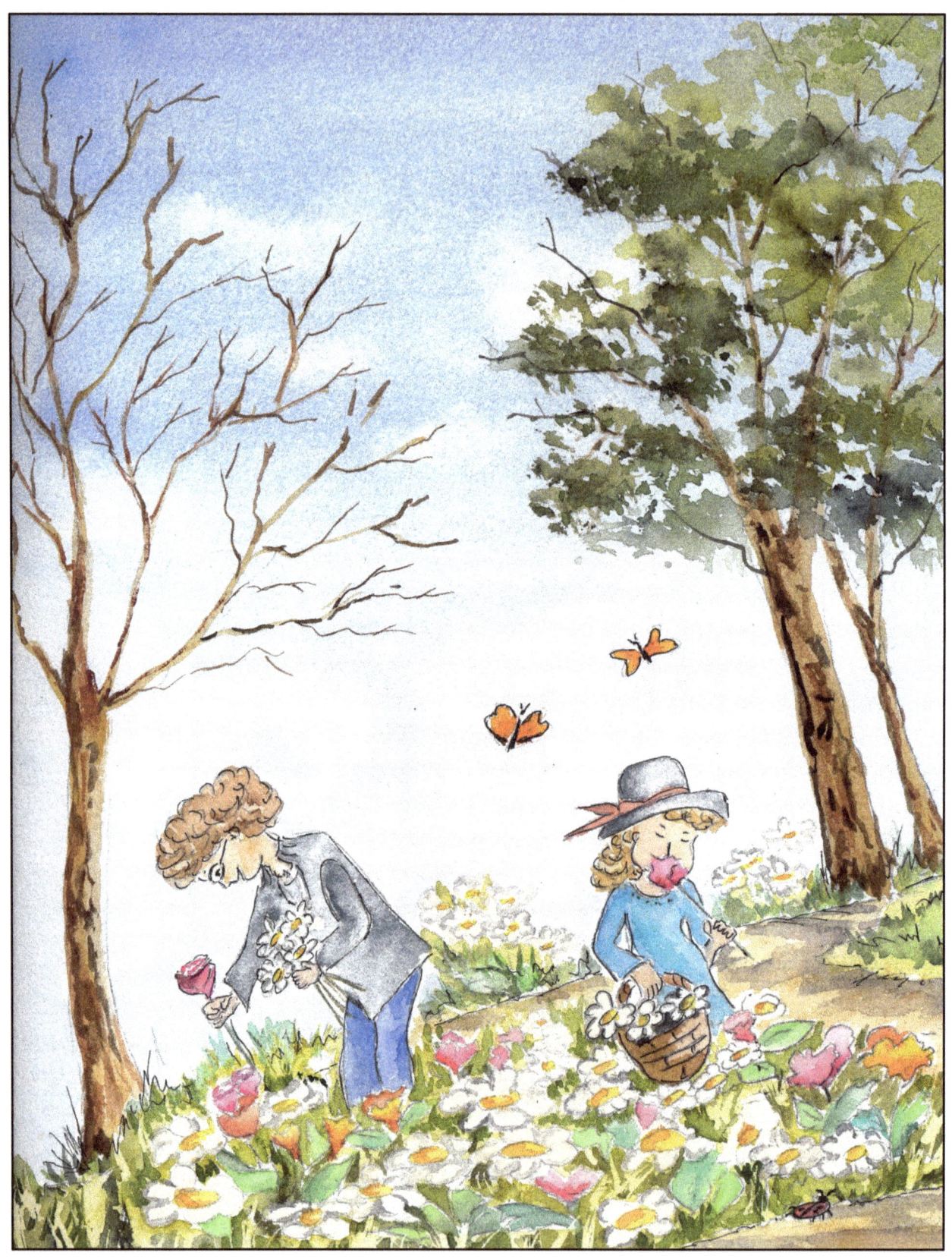

We follow those colors

We follow our nose

 We smell the flowers

 A daisy, a rose.

We explore a leaf

A dormant tree

 Treasures are there

 To hear and to see.

Horns honk, birds sing
People pass by
　　I ask Bubbe questions
　　That all end in "Why?"

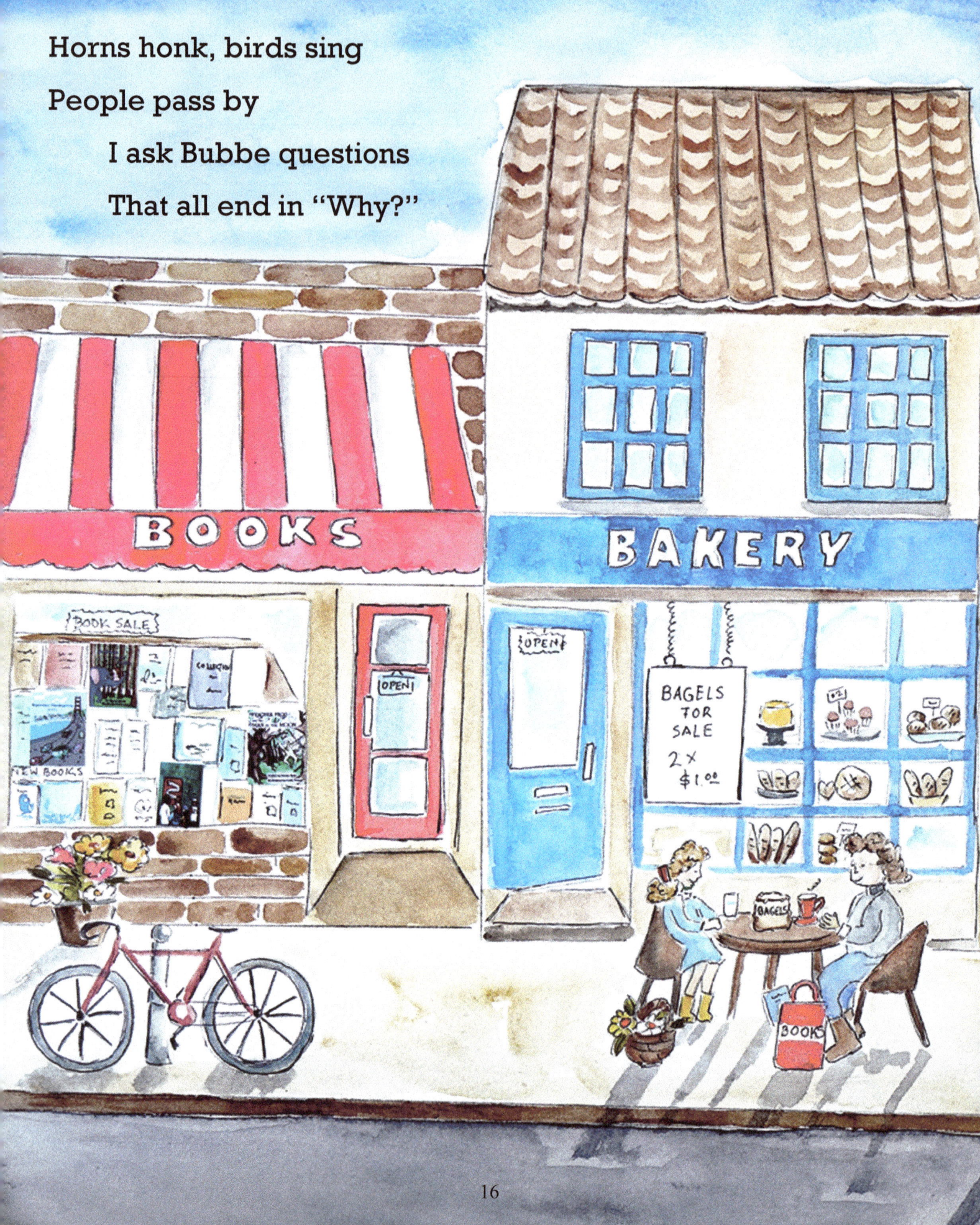

We turn the corner
Go down the street
Busy store fronts
Invite us to peek.

Bagels for sale
A sign on the door
Two for a dollar
Bubbe buys four.

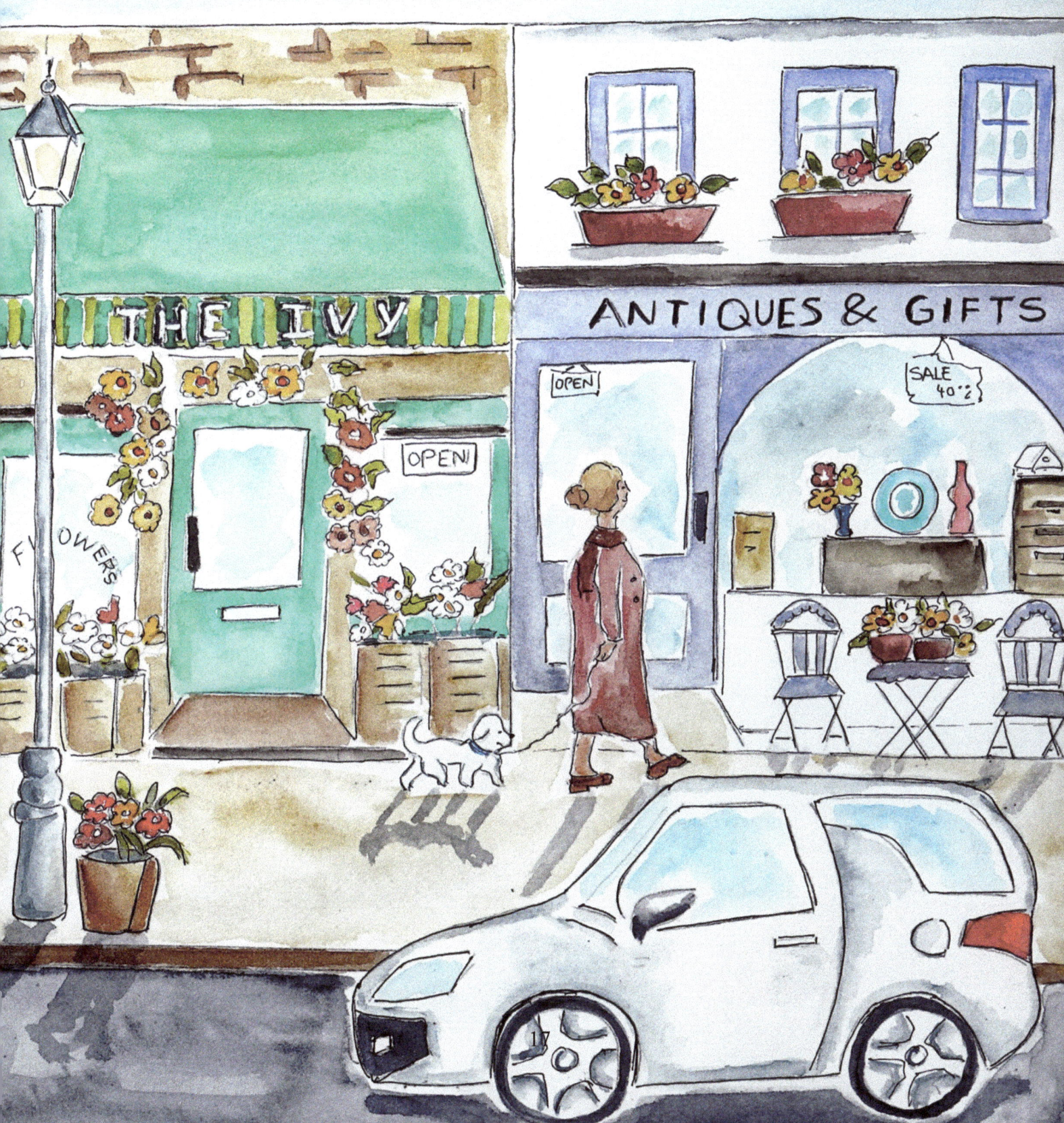

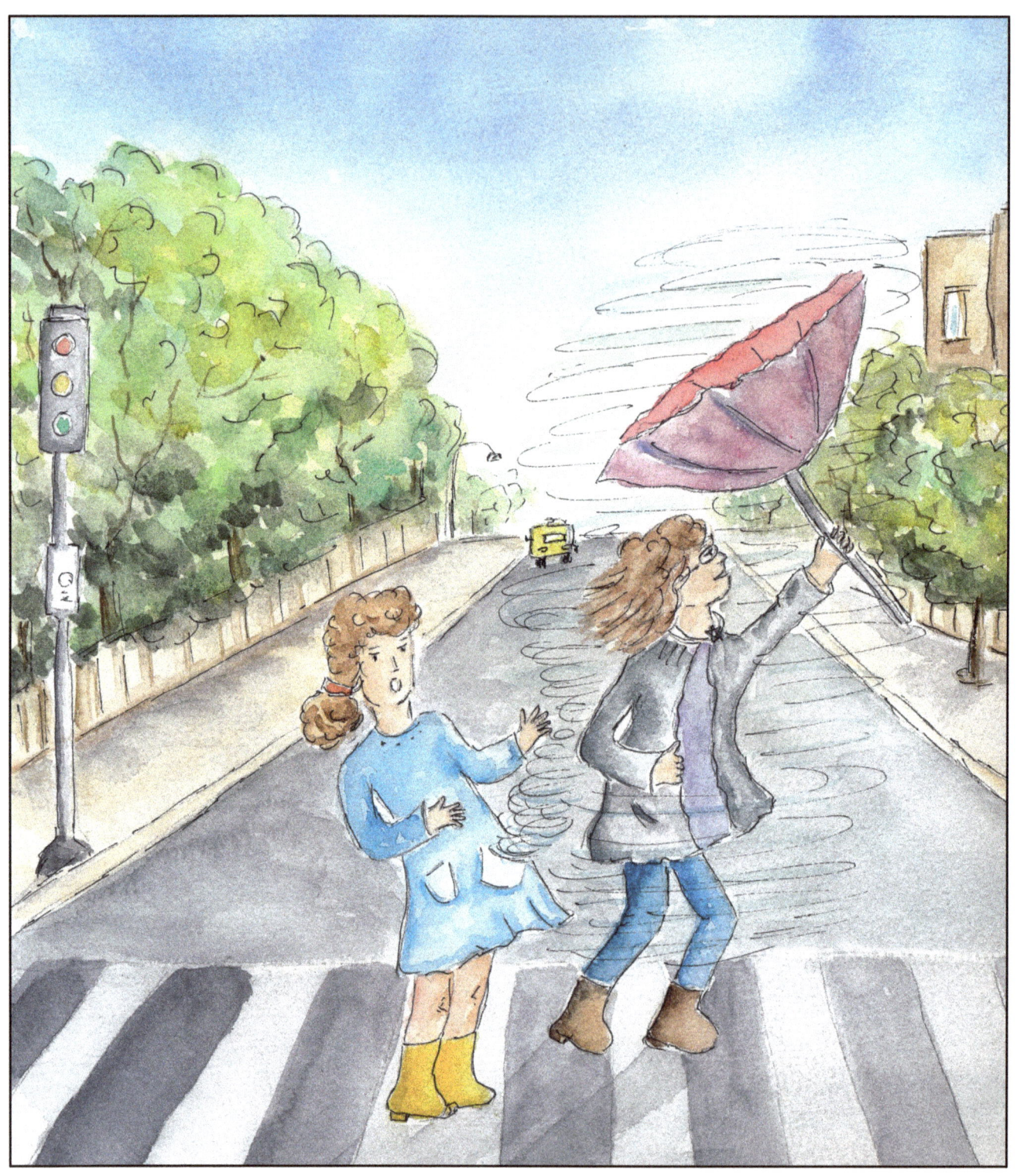

Our eyes open wide

Imaginations free

 We walk hand-in-hand

 My Grandma and me.

We follow the wind

Where ere it may roam

 Bubbe puts it in my pocket

 And we take it back home.

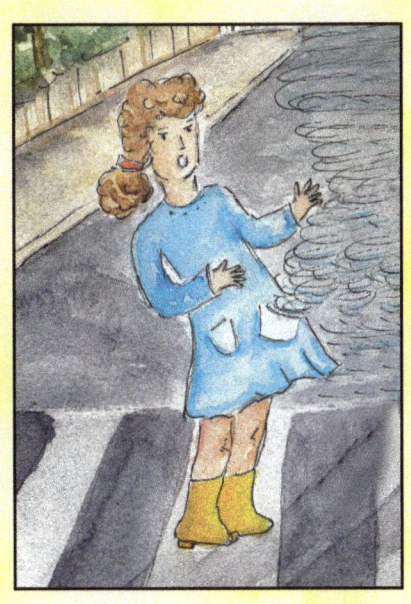

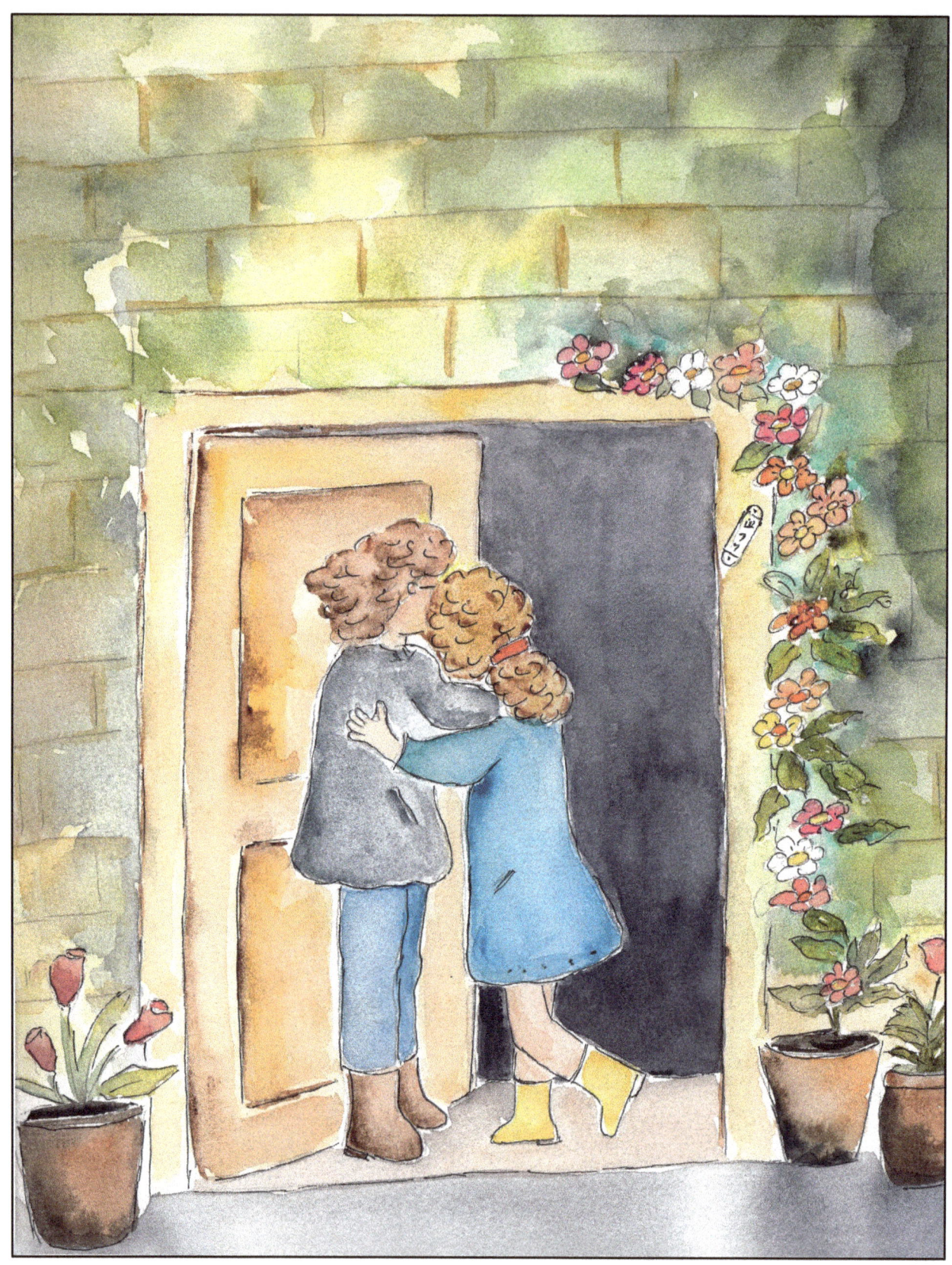

When my front door

Is back in our sight

 I hug Bubbe good

 Hug with all of my might.

We say those words

That mean I love you

 Spend time, show your love

 That's her Shabbos rule.

Time for more hugs

A kiss on the cheek

 Plan another walk

 Tomorrow, next week.

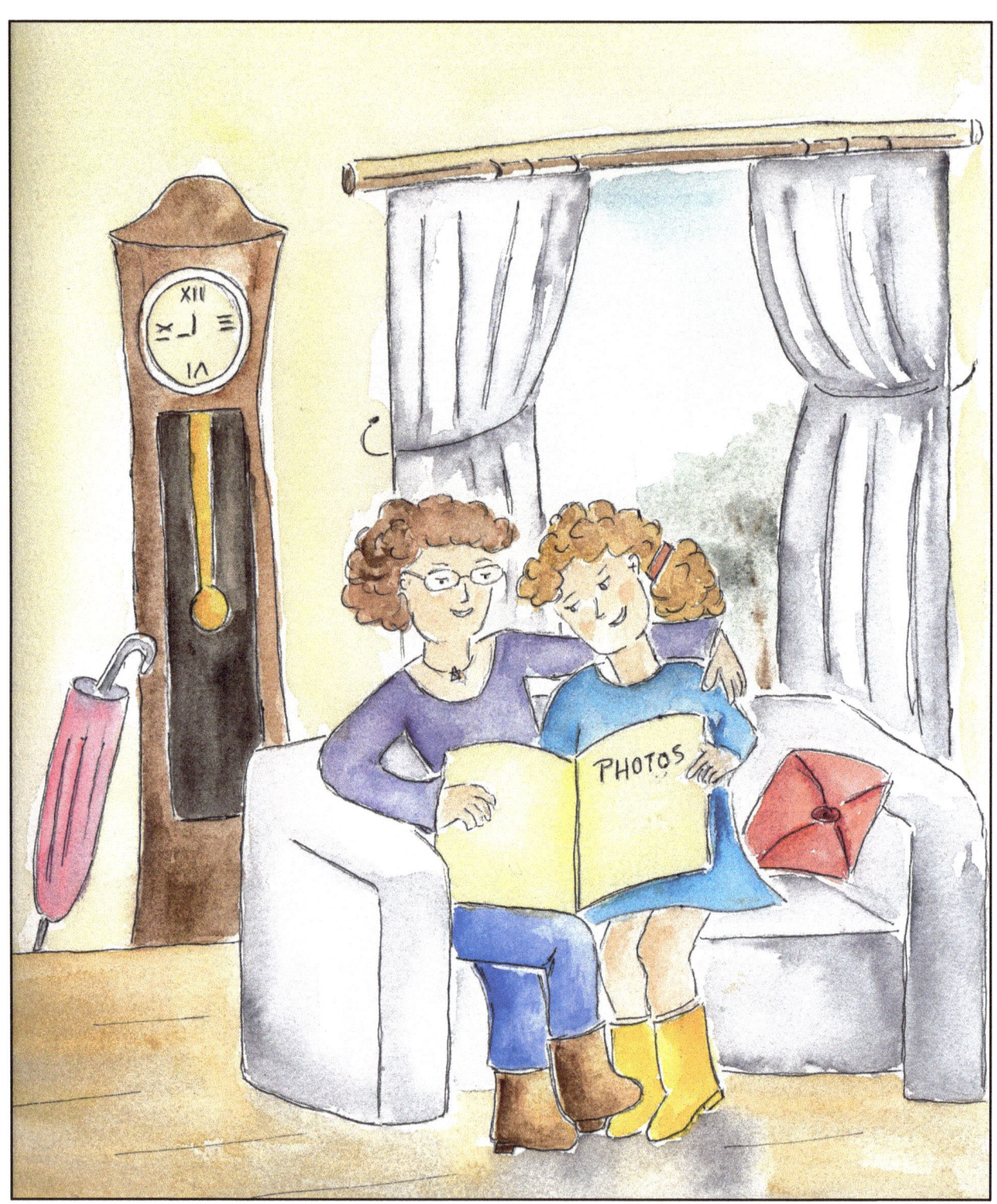

Weeks turn to months

Decades too fast

 We pause to reminisce

 Lessons learned from the past.

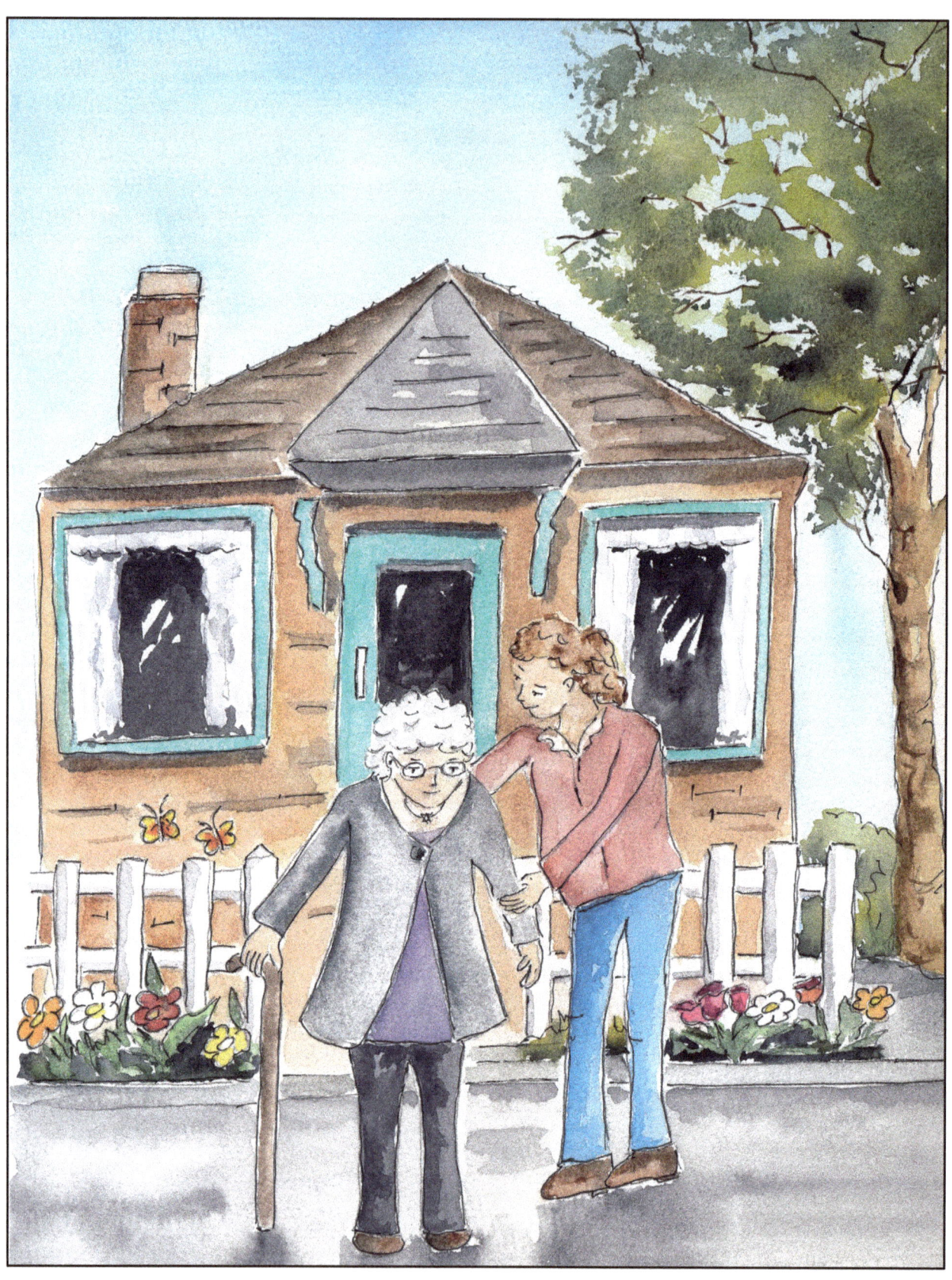

I grew strong and tall

Bubbe's short and thin

 She walks with a cane

 Her eyesight grew dim.

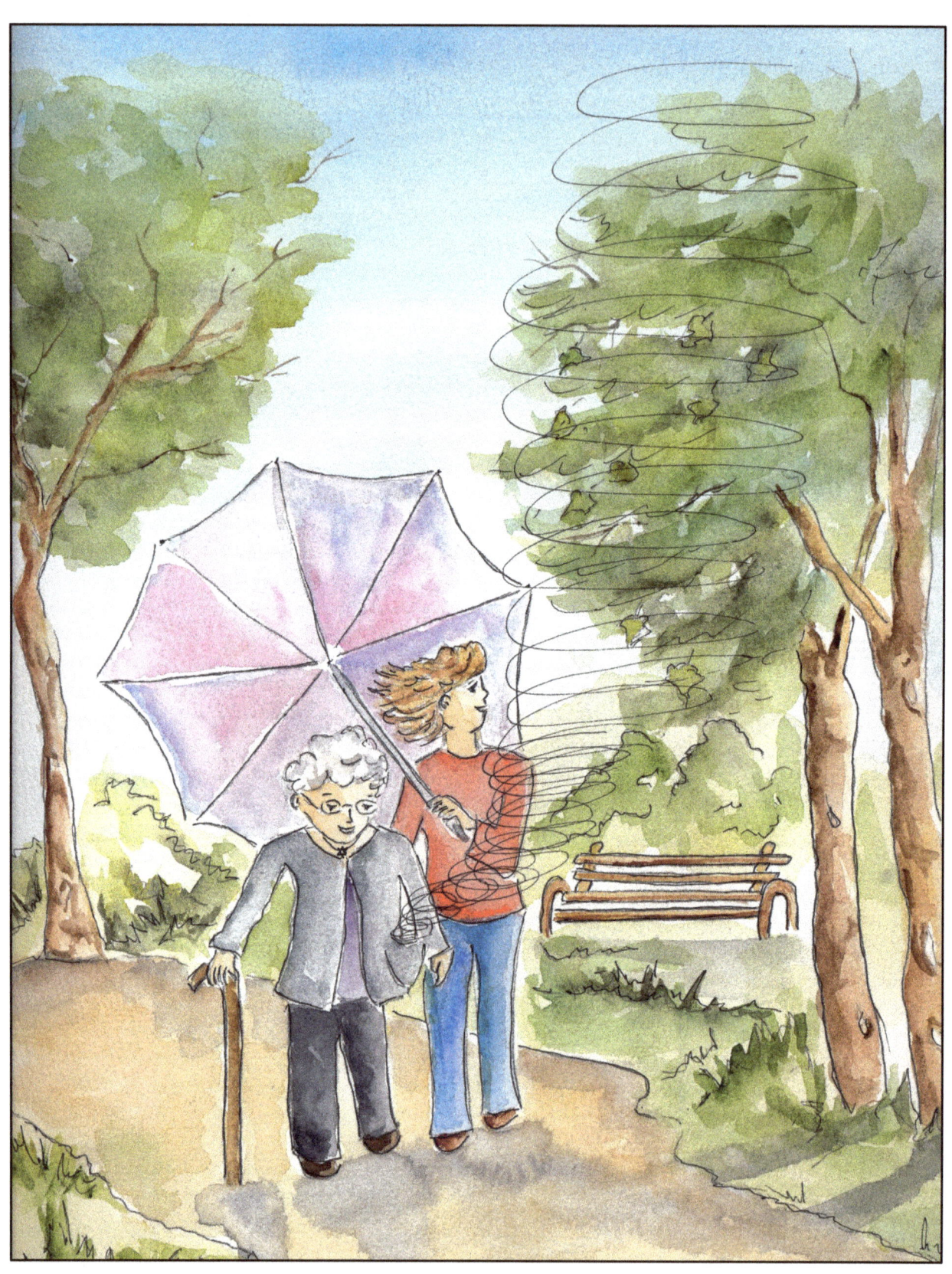

She lets **me** catch the wind

Where ere we may roam

 Now I put it in **her** pocket

 For Bubbe to take home.

We still say words

That mean I love you

 Share your time, show your love

 Now that's **my** Shabbos rule.

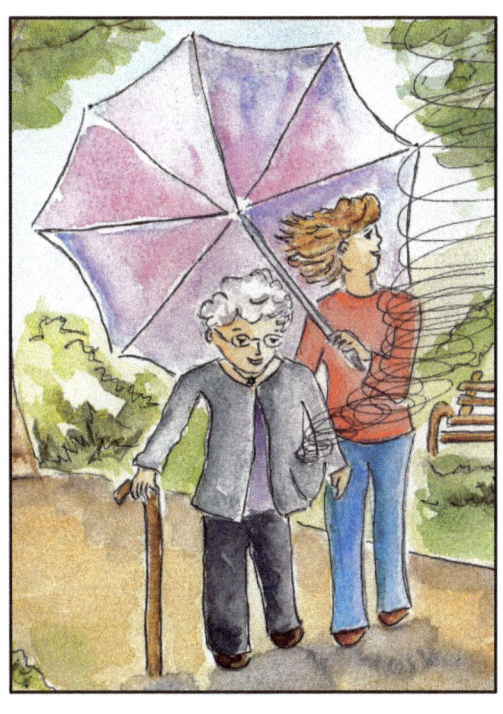

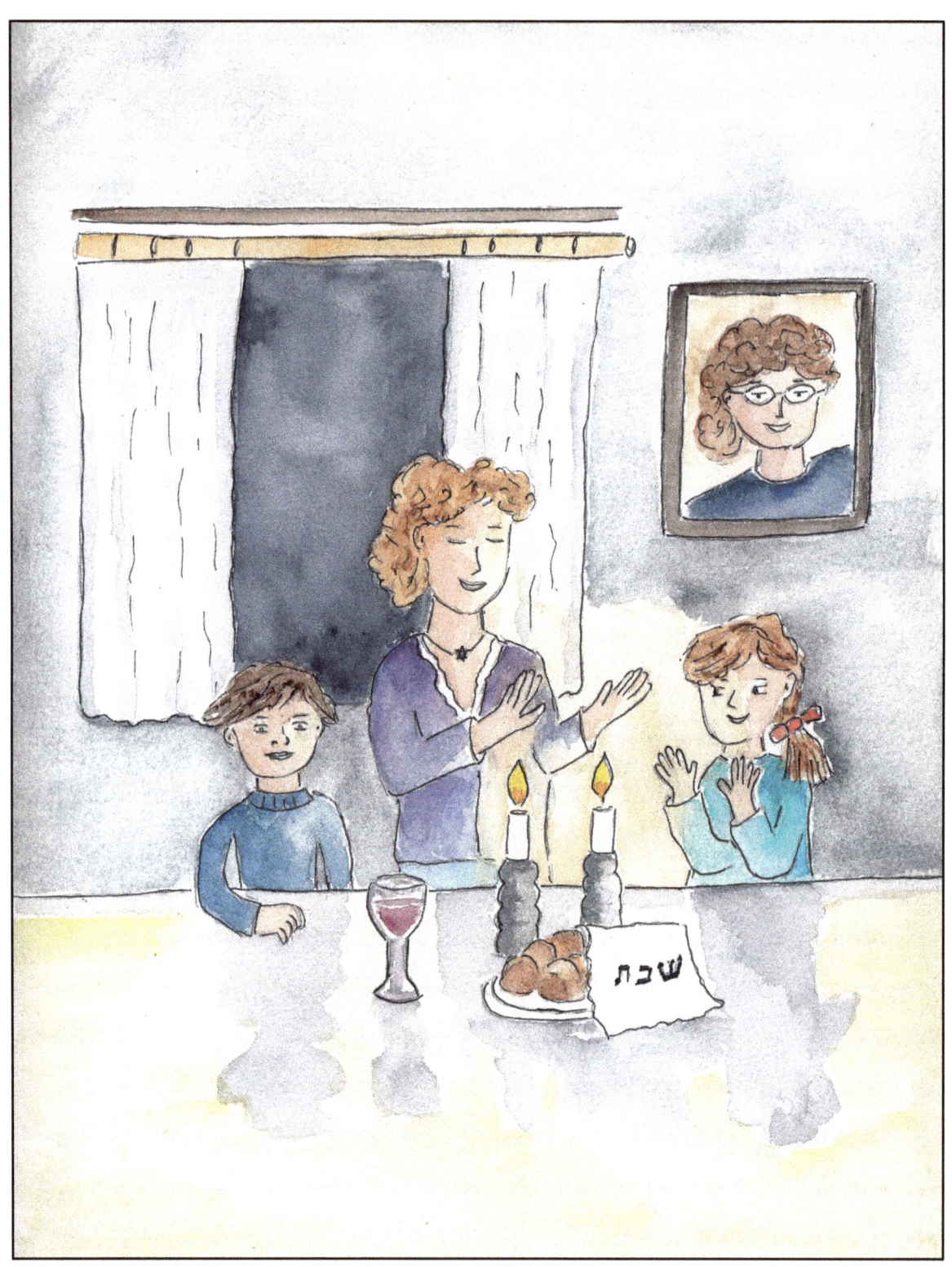

Someday I'll be a Bubbe

With one child or two

 Pass down her wisdom

 And her Shabbos rule.

I'll always follow the wind

Where ere I may roam

 And I'll love Bubbe forever

 Now my heart is her home.

About the Author

Norma Slavit, a retired Master Teacher, taught in the elementary schools of New Rochelle, New York, San Francisco and Los Gatos.

The author was newspaper editor for the JCC Community Center in Palo Alto for 13 years. Her articles and feature stories have appeared in educational journals, magazines, and newspapers. She has two published plays to her credit, and an early story appeared in the Encyclopedia Britannica reading series for children.

Norma is a member of SCBWI and the National League of American Pen Women.

Peaches, Frog and the Man in the Moon, her first book for children, is written for the five-eight year old. *The Elephant Who Had Allergies*, is for children of all ages. *September Thanksgiving* is a chapter book for the middle grades. *Pork Buns and High-Fives* is based on the memoirs of an Asian boy growing up in Silicon Valley. *Bubbe, the Wind and Me* is the author's fifth book. Each of Norma's books contain an educational component for the student, teacher and parent.

About the Illustrator

Elvira Rascov is a watercolor and ceramics artist from Colombia. There, she learned about working in watercolor and oil studying painting with, Francisco Ariza, son of Gonzalo Ariza a well-known artist.

For the past 24 years, Elvira has lived in California. The beautiful Californian landscapes have inspired her lovely watercolor and oil creations. The use of big brushes and water makes this medium a choice for her expressive paintings. She enjoys taking classes and meeting other artists that share her passion for painting.

Elvira received the Achiever's Art Award from the National League of American Pen Women in 2019, and became a member of the organization in January 2021. Her art exhibits have been shown in several California galleries. She also teaches watercolor classes at the Los Gatos-Saratoga Community Education and Recreation Center.

Working on the book "Bubbe the Wind and Me" is the first book Elvira has illustrated. She says it was a most enjoyable experience, and she hopes to continue illustrating more books.

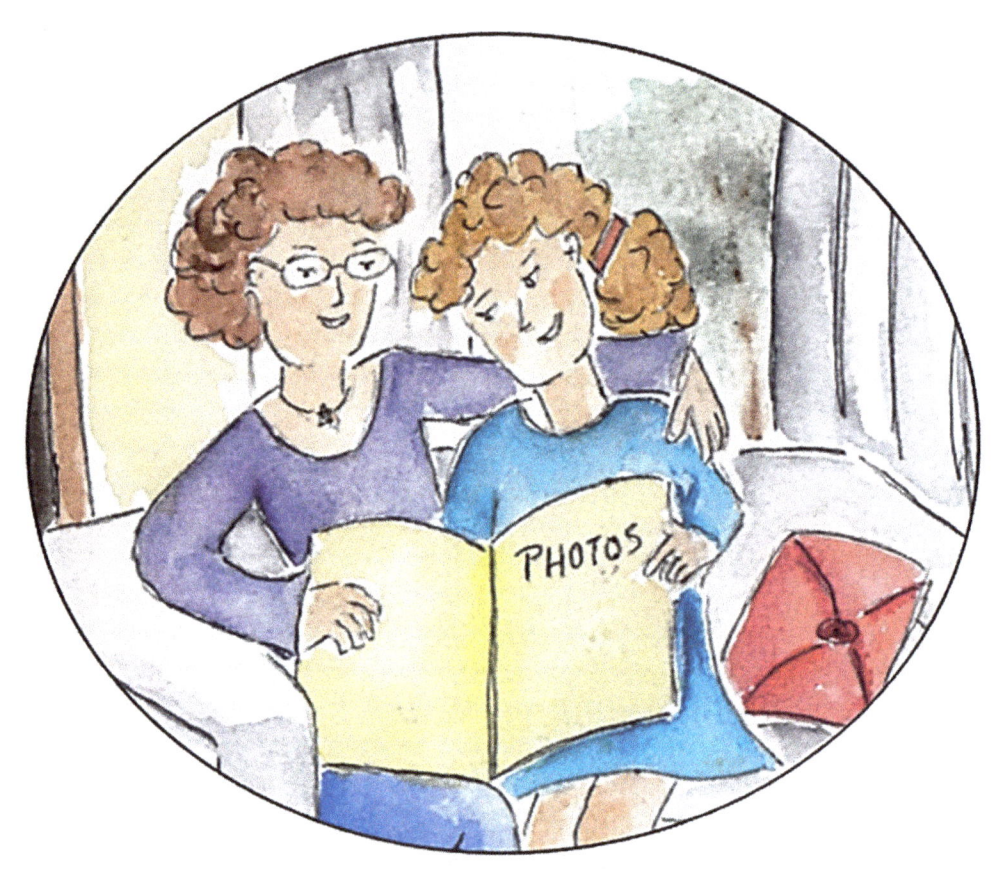

Pictures From Grandma's Photo Album

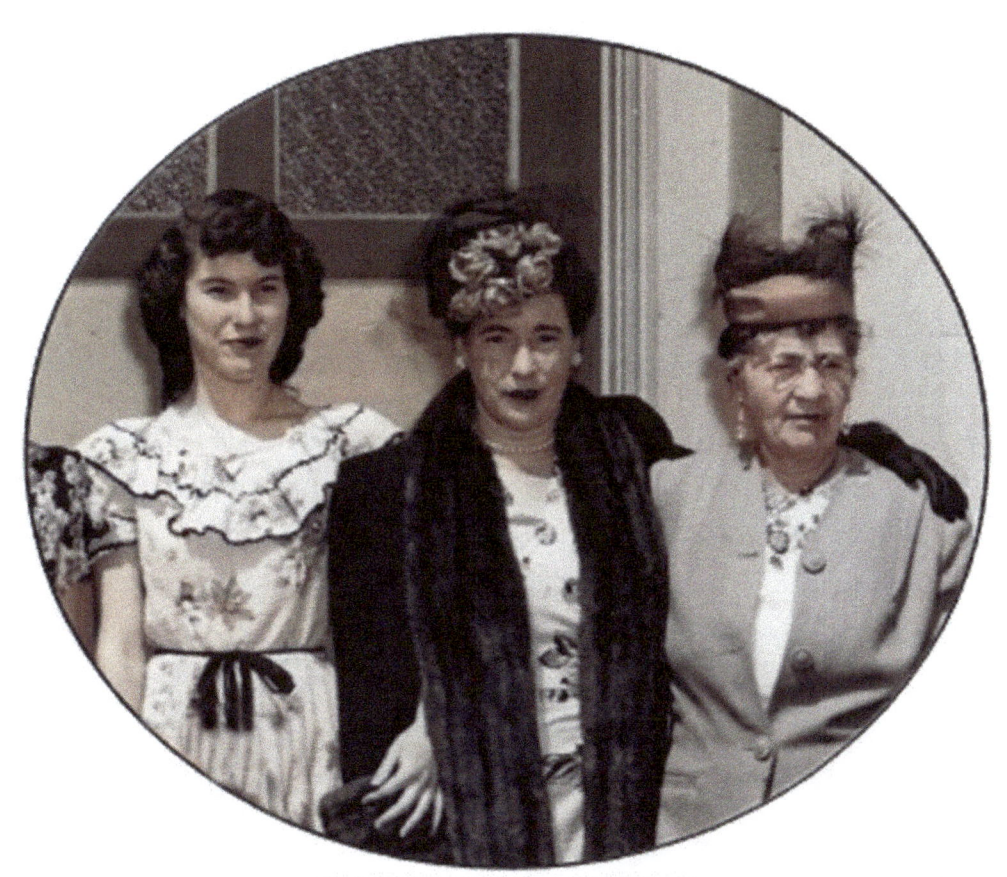

The Kaufmann § Singer Family

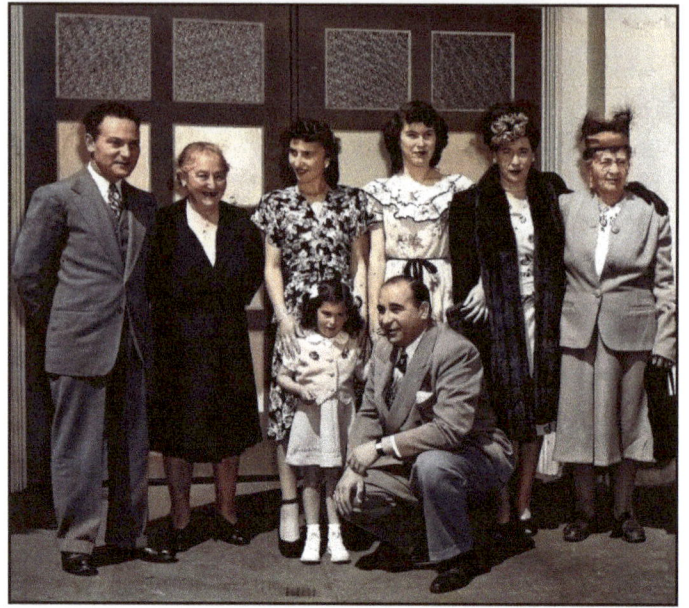

Left to right: Max Kaufmann, Norma's father (1909-1999); Martha Kaufmann, Max's mother; Else Kaufman Singer, Martha's daughter; Norma Kaufmann, next to her mother, Rose Singer Kaufmann, (1908-1998); next to her mother, Hannah Singer (1890-1950); Louis Singer, (Hannah's son) kneeling down with his daughter, Lucille Singer.
c. 1944 San Francisco, Calif.

Max and Rose Kaufmann
Parents of Norma Kaufmann Slavit

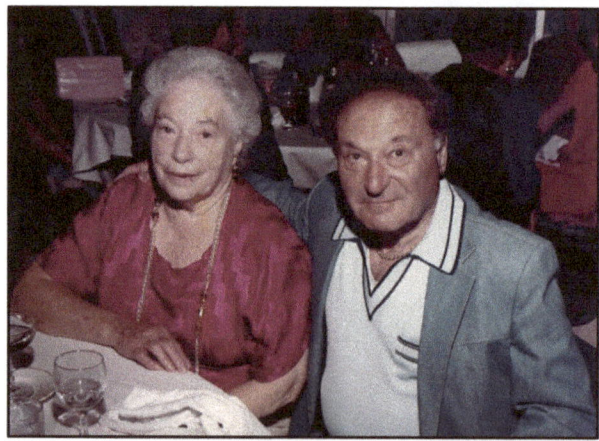

Max and Rose Kaufmann
Parents of Norma Kaufmann Slavit

Max and Rose married in 1930 during the days of the Great Depression. No wedding photos, no honeymoon, no money. They both returned to work two days after they married.

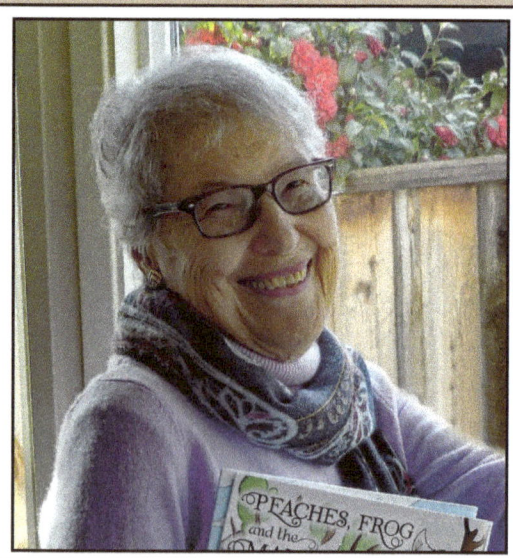

Norma Kaufmann Slavit
Daughter of Max and Rose Kaufmann

Abraham and Beatrice Slavit
Parents of Sylvia and Herb Slavit

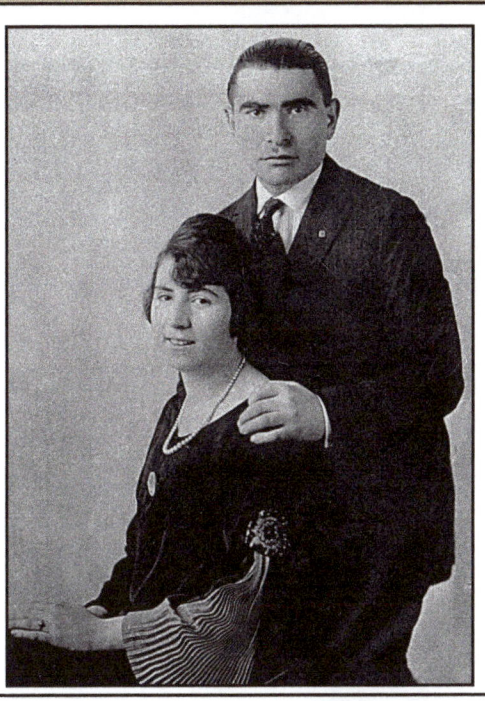

Abraham (1898-1983) and Beatrice Slavit (1897-1994)
New York City

Their children (below)
Sylvia Slavit Levy (1924-1984) and Herb Slavit (1931-2004)

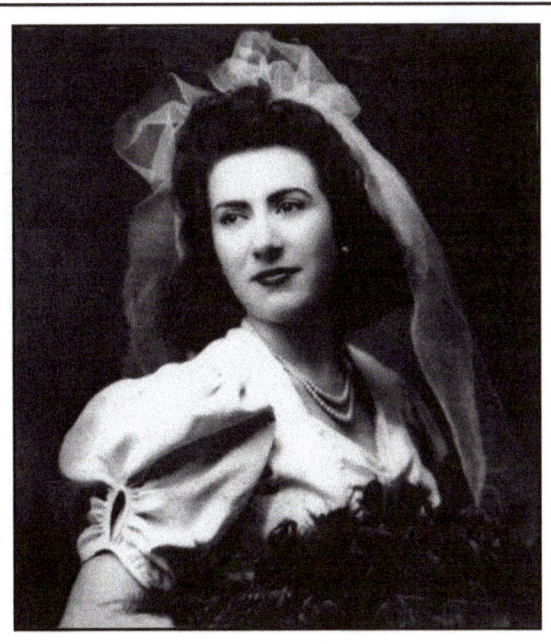

Herb and Norma Kaufmann Slavit

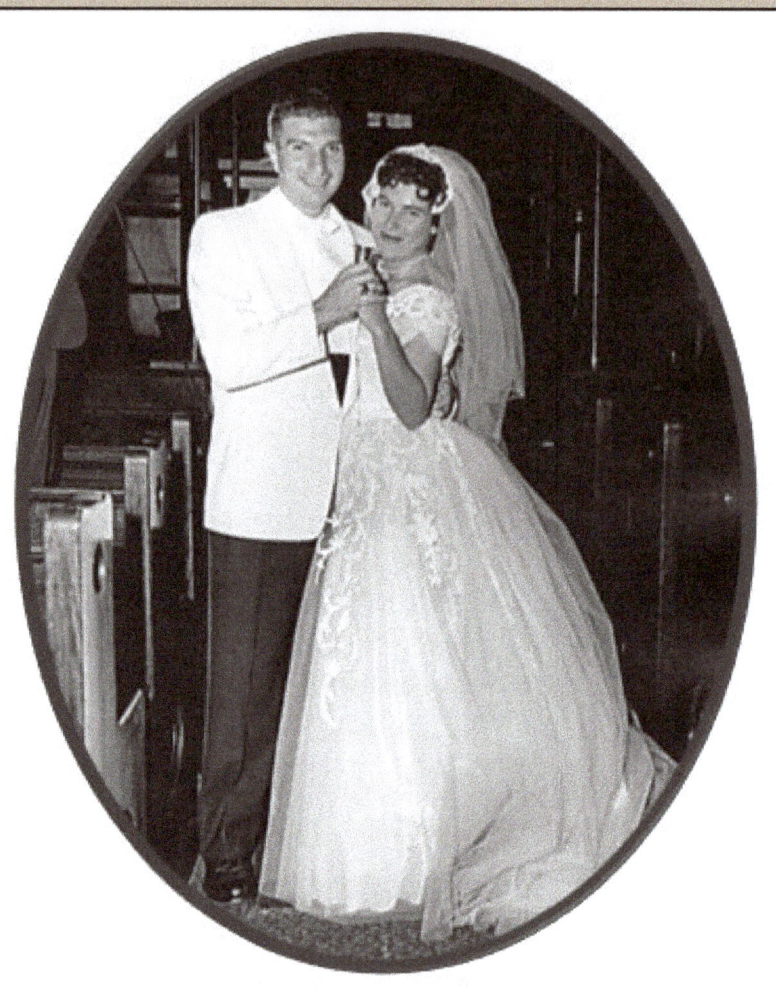

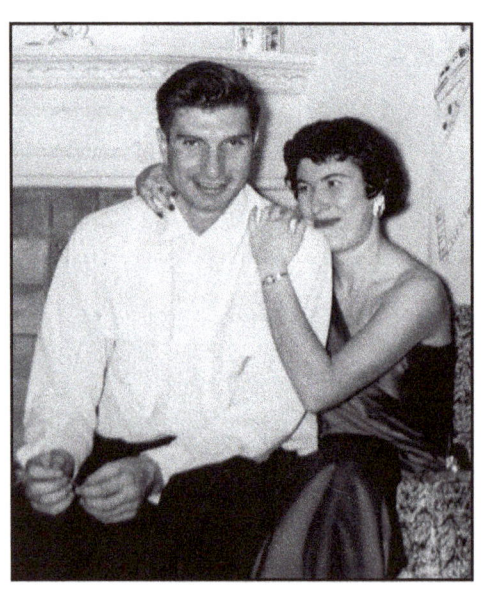

Mr. & Mrs. Slavit

**Herb Slavit
And
Norma Kaufmann**

Marriage Ceremony
Temple Beth Israel,
San Francisco
August, 1956

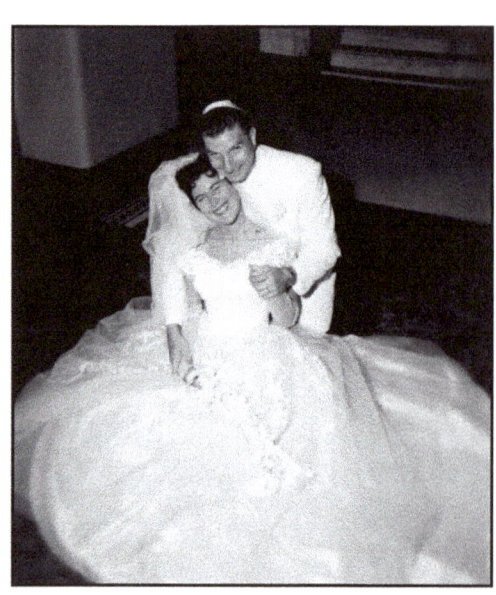

Joel and Lisa Slavit
Children of Herb and Norma Slavit

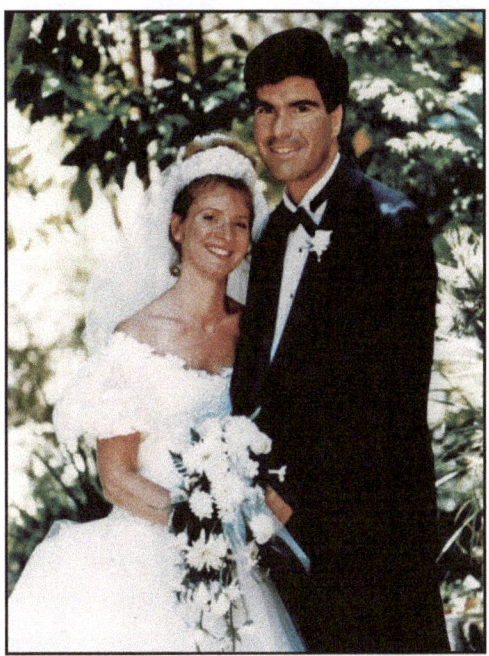

Left side photo
Joel and Betsy Slavit
c. 1995

Right side photo
Steve and Lisa Slavit Barkin
c. 1997

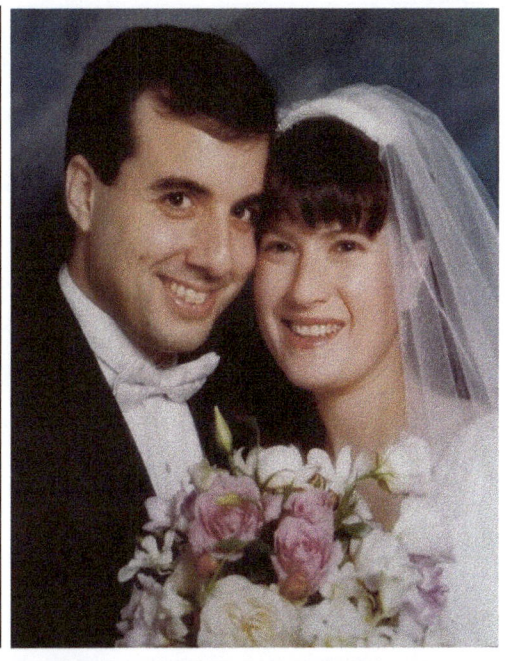

Surprise! Birth Announcement of Joshua Barkin

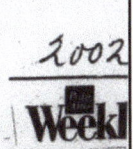

BABY ON BOARD . . . With the help of local firefighters who arrived just in the nick of time, Palo Alto resident **Lisa Barkin** gave birth to a healthy baby boy on her Maureen Avenue front lawn Sept. 23. During the speedy delivery that began around 12:30 p.m. and ended abruptly at 3:22 p.m., Barkin's husband, Steven, tried to help her to the hospital but the pain and rapid progression of her labor proved too much and they nixed the car trip and instead called 911. Firefighters from the Mitchell Park station arrived about four minutes after they were alerted and assisted in the delivery of 8 lb., 9 oz. **Joshua**. Barkin praised her last-minute birth coaches, saying, "The firefighters were absolutely fantastic and they're just so skilled." She also added, "Thank goodness the sprinkler system hadn't turned on yet."

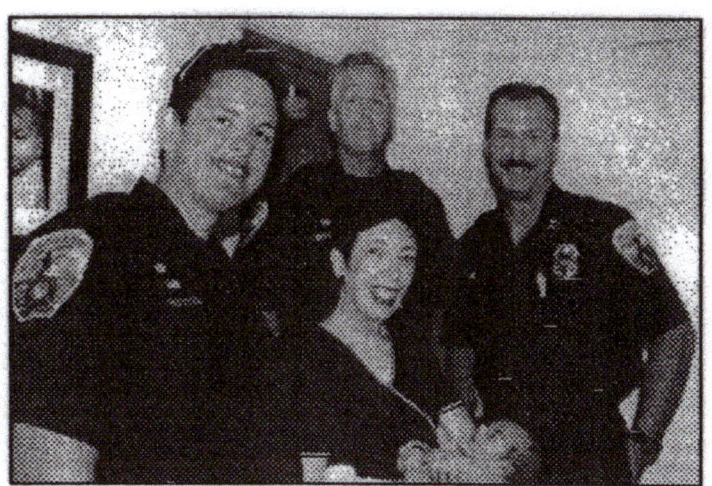

Photo credit: Norma Slavit

Then and Now - Grandchildren of Herb and Norma Slavit

 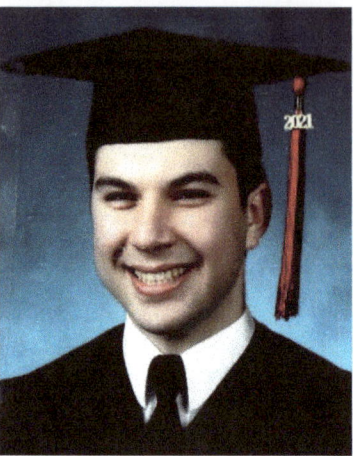 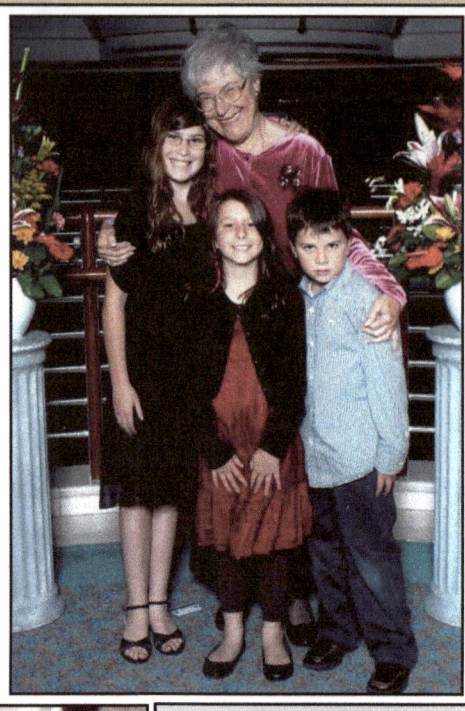

Joshua Barkin
Graduate of Gunn High 2021
Son of Steve and Lisa Barkin

Top right: **Norma** and her three grandchildren

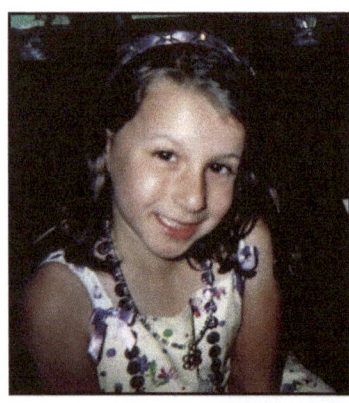 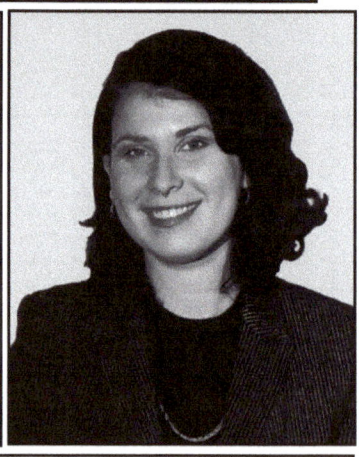

Two photos on the right

Ilana Slavit
Graduate of University of Oregon 2020
Daughter of Joel and Betsy Slavit

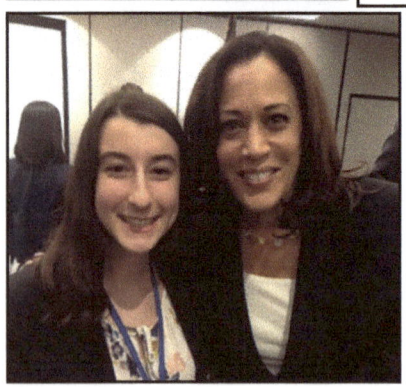

Two photos on the left

Rachel Barkin
Junior at Barnard University, New York
Daughter of Steve and Lisa Barkin

Pictured with Senator Kamala Harris, now Vice President of the United States

Some of My Greatest Treasures Call Me Grandma
Loving Thoughts from Norma's Grandchildren

Ilana Slavit

I greatly treasure the time I spent with my Bubbe, Grandma Norma, on our walks. Her dedication to education and creativity is truly inspiring and influenced my passion for the arts. Hopefully, we can go on another walk soon, and this time I'll buy her some 'two for one' bagels.

Ilana Slavit
2020 graduate, University of Oregon

Rachel Barkin

You are an amazing woman! Thank you for always being there for me and know that I will always be there for you. Thank you for teaching me empathy and resilience.

Rachel Barkin
2020 Barnard University junior

Joshua Barkin

"Everyone dies twice; the first time when your heart stops beating, and the second when you're forgotten."

I think about my Grandma's strong presence in my life: her words of wisdom, the music she plays on the piano, and her Ziploc bags filled with assorted chocolates. I don't want Grandma Norma or her kindness to be forgotten. For the past three years, I've been recording her as she shares stories of her parents, grandparents, and past experiences. (Over six hours of recording, so far). I was riveted when she explained how her Grandma escaped the deadly grasp of Nazi Germany, leaving her entire family behind. I admired her strength when Grandma's first serious boyfriend, Louis, proposed to her, but she made the difficult choice to attend college over marriage. I played "Teach me Tonight," her favorite song with my late Grandpa Herb, while she shared the memory of dancing with him. Listening to her grapple with the emotions of deep love, grief, and pure joy, I learned that listening isn't just about hearing words, but also feeling what those words convey. I'm eager to pass on her memoirs, so that my Grandma and our ancestors continue to live on in memories of their experiences which I hope to share with my family.

Joshua Barkin
Gunn High School senior, 2021

Grandmothers

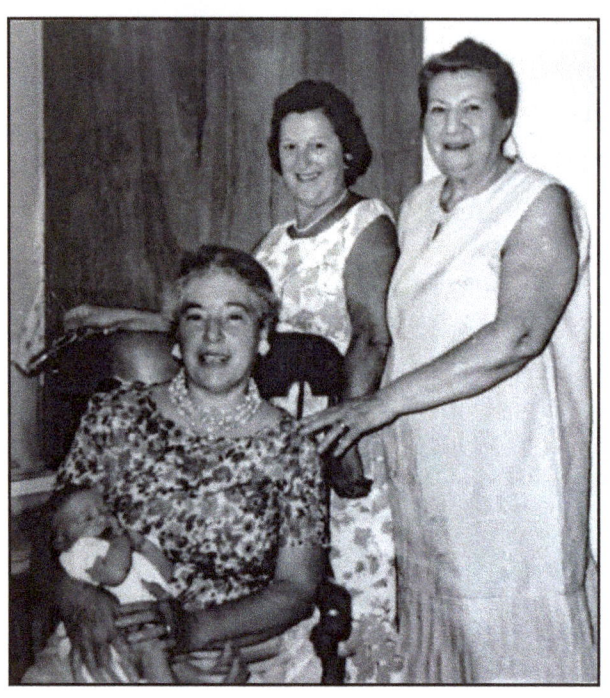

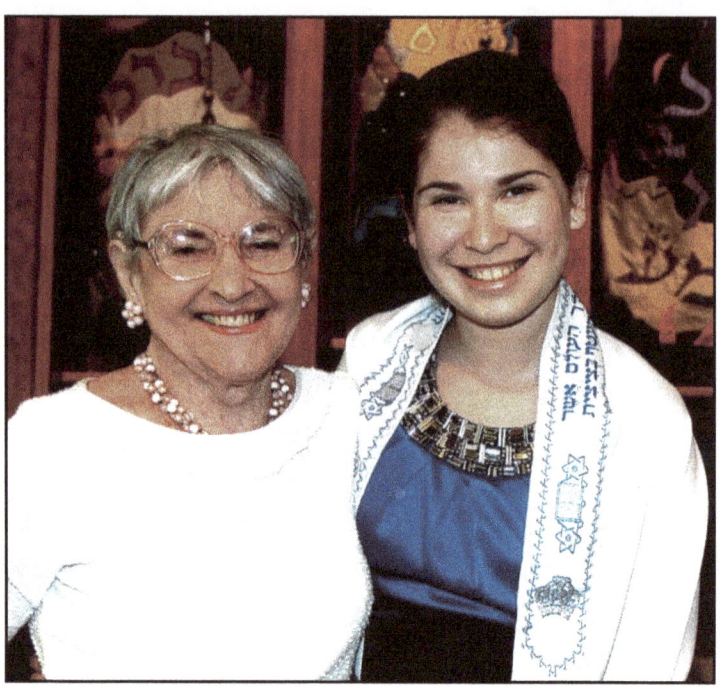

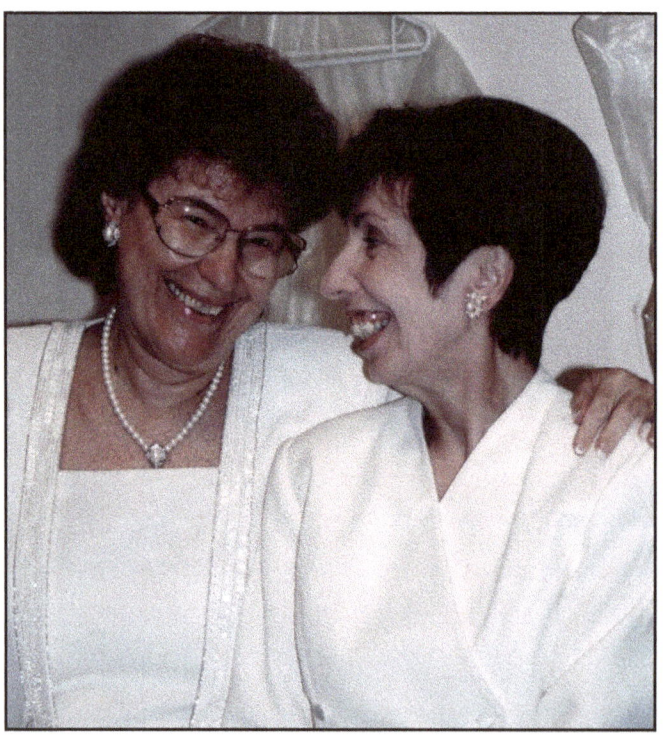

Proud Grandmothers
Top left:
Grandma, Rose Kaufmann, seated with baby Joel, an unknown family friend, and **Grandma, Bea Slavit**

Top right:
Grandma, Doris Bobb, at granddaughter, Ilana Slavit's Bat Mitzvah

Bottom left:
Grandmothers, **Norma Slavit** and **Kay Barkin,** at the wedding of Steve and Lisa

First Cousins

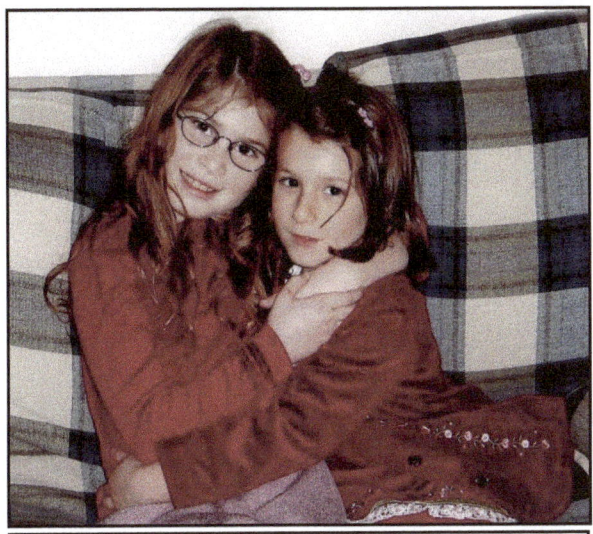

**Left to right
Ilana and Rachel**

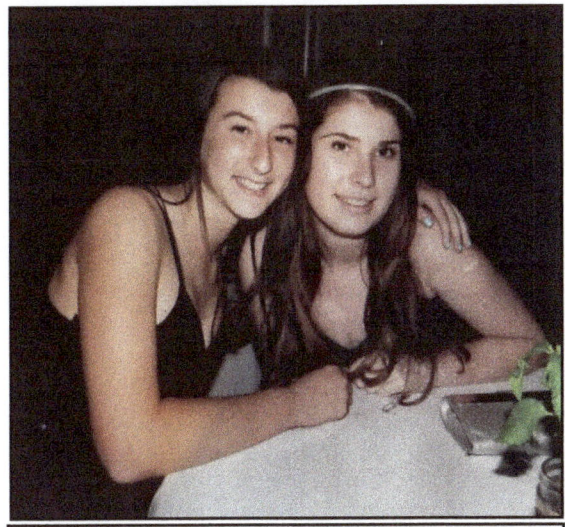

**Left to right
Rachel and Ilana**

First Cousins Then and Now

Rachel Barkin and **Ilana Slavit**

Children of Steve and Lisa Barkin & Joel and Betsy Slavit
Granddaughters of Herb and Norma Slavit
Great-Granddaughters of Max and Rose Kaufmann & Abraham and Beatrice Slavit

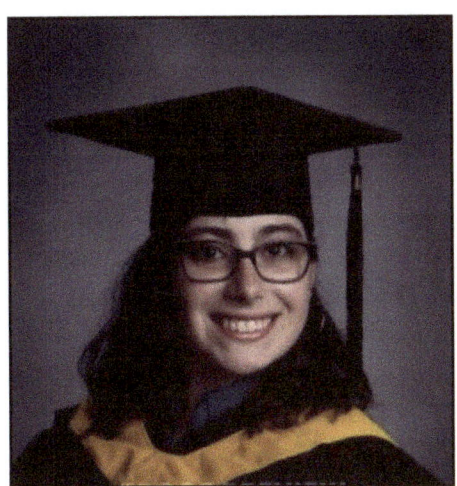

Miranda Reisch

2020 Graduate of Worcester Polytechnic Institute, Massachusetts

Daughter of Lou and Susan Reisch, Granddaughter of Lucille Singer & Stanley Reisch, Great-Granddaughter of Else and Louis Singer.

The Next Generation

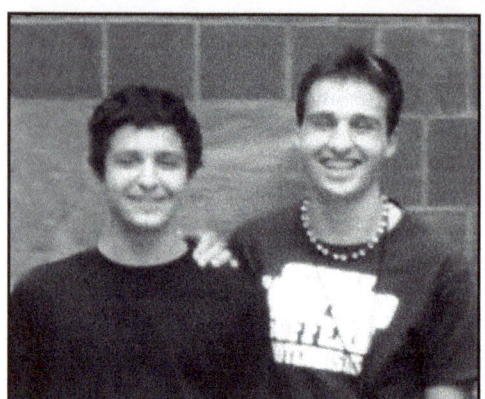

Top left

Jason and Bret Silverstein

Sons of Lori and Jerry Silverstein Grandsons of Sylvia and Bert Levy, Great-Great Grandsons of Beatrice Slavit, nephews of Arlene Levy Gottstein and George Levy

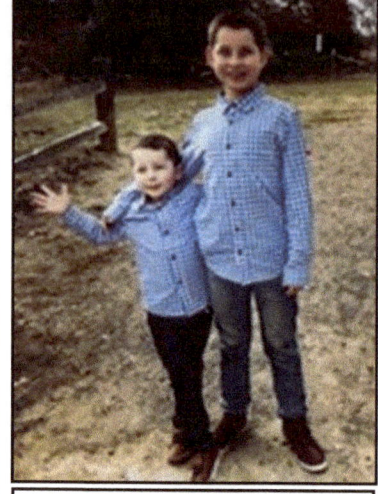

Left to right:

Paul Levy; Dr. Eric Levy; **George Levy**, son of Sylvia and Bert Levy; Sherry Levy, wife of George Levy

Front: Dr. Amy Levy, wife of Eric Levy, holding baby Elizabeth

Top right

Theo and Jayden Shank

Sons of Jessica Cohen Shank, Grandsons of Susan Cohen, Great-Grandsons of Maxine Cohen, Great-Great-Grandsons of Hannah Singer Cohen

Elizabeth Levy, and new born sister, **Emma Lilly Levy**
The two children of Dr. Eric and Dr. Amy Levy

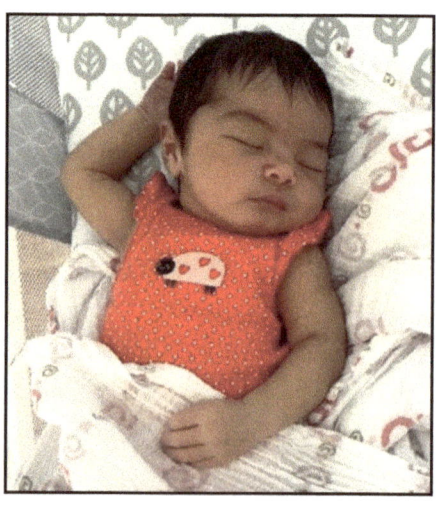

What was Happening in the World at the Time This Book was Written
August 2021

In July of 2021, the deadly coronavirus (aka Covid-19), had claimed the lives of approximately 4.16 million people world-wide.

During the same time, approximately 610,000 Covid-19 deaths were reported in the United States.

In my state of California, the reported coronavirus death total was approximately, 64,500 deaths. (According to Google statistics)

Sometime in August, a new Covid-19 variant was plaguing the world. It was called the delta variant.

What was Happening in My Family at the Time This Book was Written

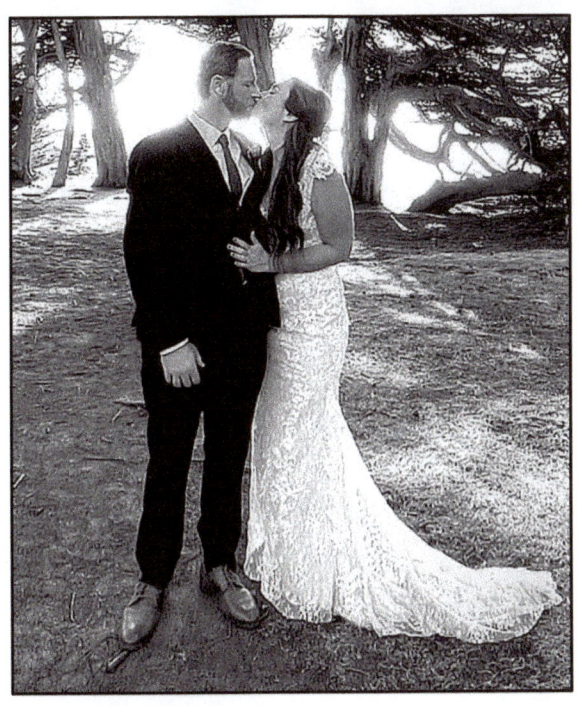

THE WEDDING OF ASHLEY AND RYAN CHANDLER
Daughter or Mr. and Mrs. Susan Cohen, Granddaughter of Milton and Maxine Cohen, Great Granddaughter of Hannah Cohen

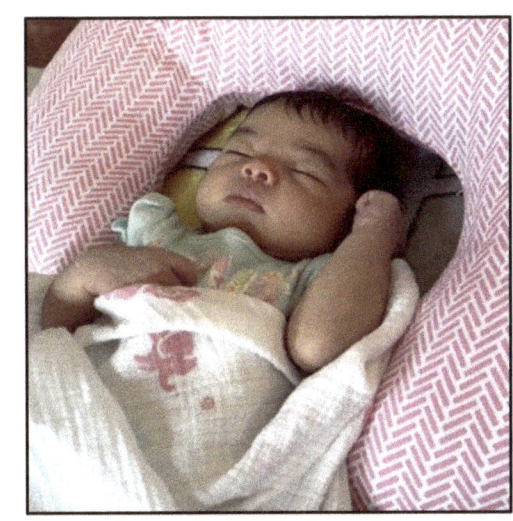

THE BIRTH OF EMMA LILLY LEVY, August 2021
Daughter of Dr. Eric and Dr. Amy Levy, sister of Elizabeth Levy, granddaughter of George and Sherry Levy, Great-Granddaughter of Sylvia and Bert Levy, Great-Great-Granddaughter of Bea Slavit.

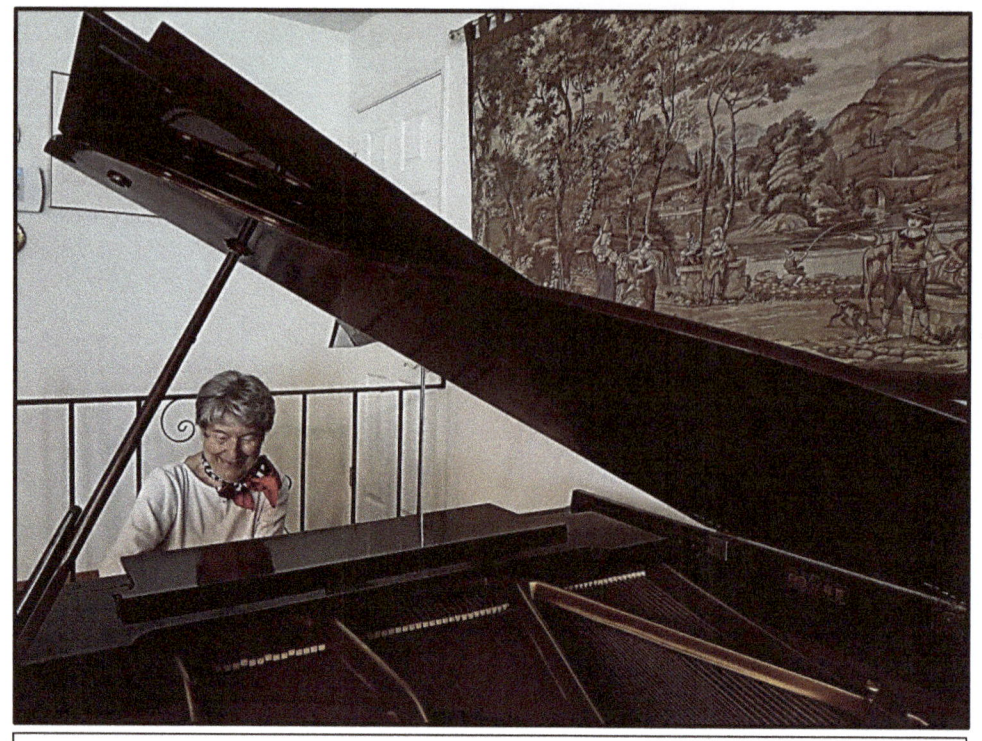

Norma Slavit

September 22, 2021

At home in San Jose, California

Dear Grandma,
I love it when you play the piano and the music floats through the room.
Love, Rachel
Written by Rachel Barkin at age 11

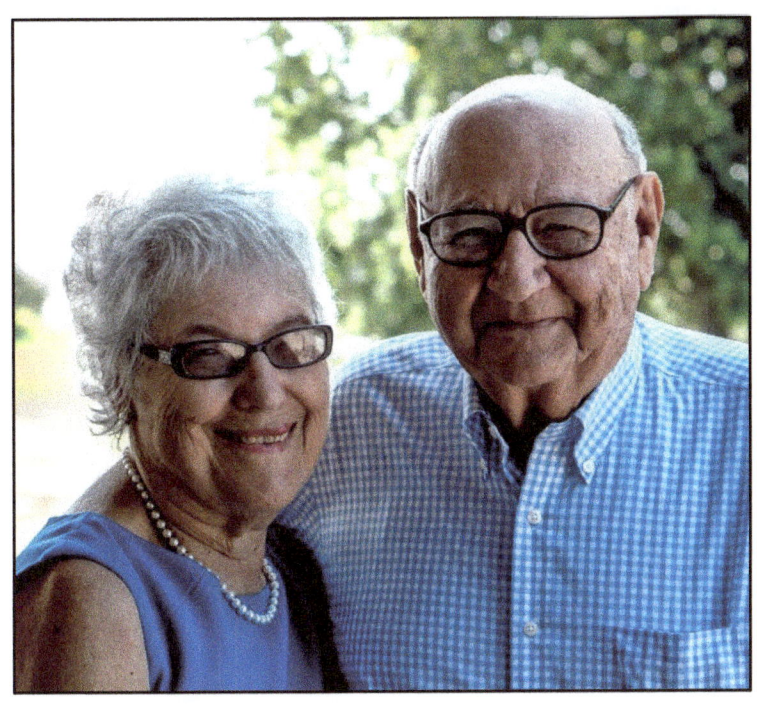

Norma Slavit and Paul Staschower
In 2021 Norma marked her 90th birthday and her fiancé, Paul, celebrated his 95th year.
They wish you good health, good fortune and happiness.
L'Chaim

At the time this book was completed, the world was in turmoil with the deadly coronavirus and the delta variant taking a toll on the lives of people everywhere. Events and celebrations were modified or cancelled. Life went on, and Norma and Paul celebrated their milestone birthdays quietly in the privacy of their home.

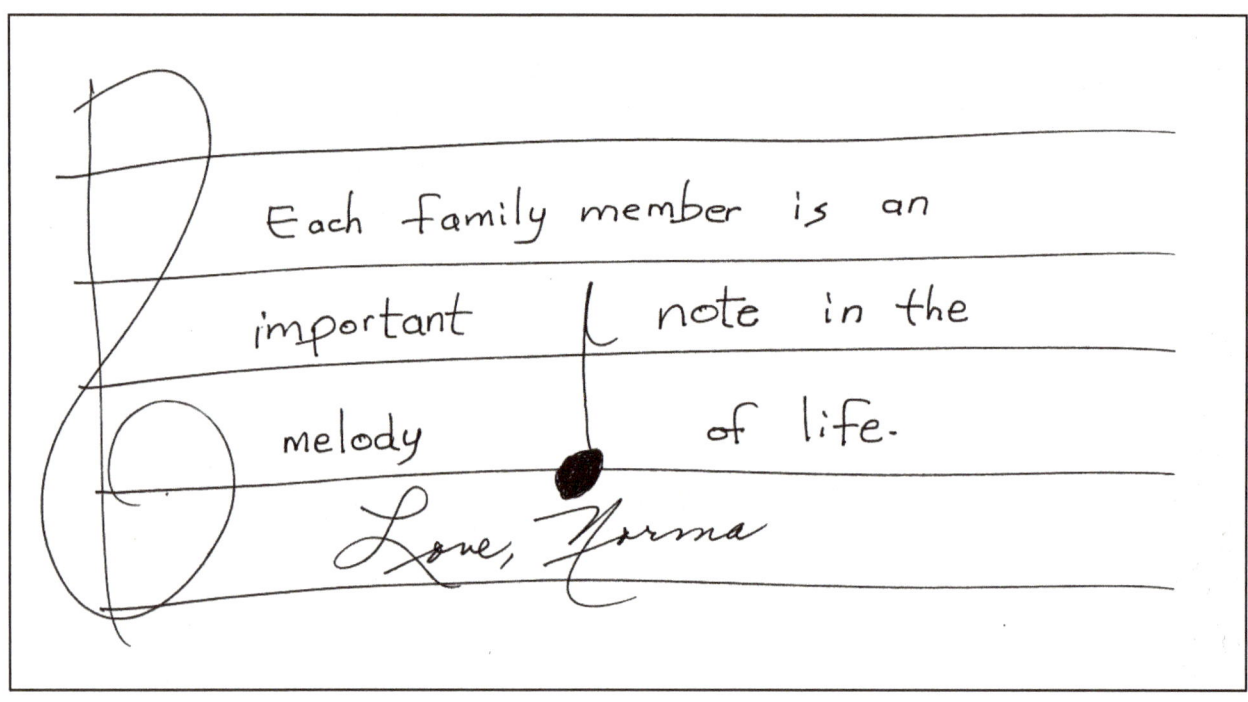

Each family member is an important note in the melody of life.
Love, Norma

www.ingramcontent.com/pod-product-compliance
Lightning Source LLC
Chambersburg PA
CBHW041921180526
45172CB00013B/1351